BARRON'S ART HANDBOOKS

ACRYLICS

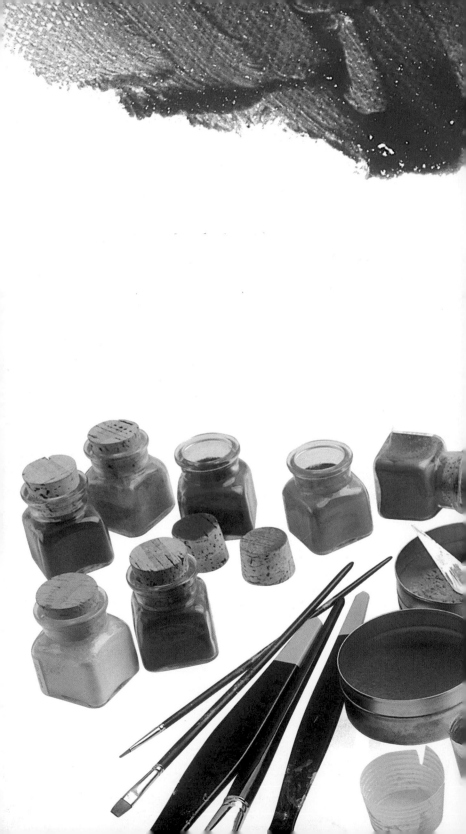

BARRON'S ART HANDBOOKS

ACRYLICS

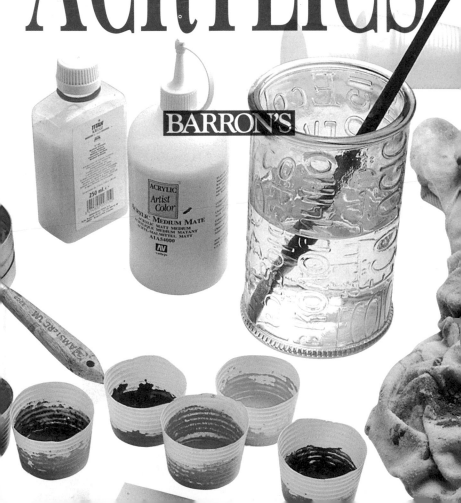

BARRON'S

SUMMARY

TECHNICAL EVOLUTION
IN PLASTIC ARTS

For centuries, oil was the medium most favored by artists. Because of its versatility, artists replaced other media, such as egg tempura and caseins, with oil. The ever-bright, freshly painted look of oil colors became the favorite means of expression for artists up to the present time, but recently a new medium has emerged that, though originating in the industrial world, has found a place in every style of contemporary art.

From Oils to Acrylics

Acrylics have become the medium of choice for many artists, even those who were trained in oils or other media. The reason many artists switched to acrylics became obvious after they experimented with the different techniques. Though not meant to replace any media, acrylics are clearly capable of producing effects that rival the chromatic and textural stability of oils. One of the main advantages that acrylics have over other media is that they dry almost immediately, allowing an artist to work quickly and finish a paint-

A Brief Overview

Acrylic colors were invented in the mid-nineteenth century but came into commercial use only in the 1930s—for industrial rather than artistic purposes.

Following the development of new styles and painting media by the first artistic vanguards in the 1940s, several American artists began experimenting with the acrylic paints that were in heavy use in industry. The introduction of the paints into contem-

Morris Louis (1912–1962), Blue candle. *Fogg Art Museum, Harvard University, Cambridge, Massachusetts. Acrylic watercolor treatment.*

porary art gave way to new technical options of expression that competed with every medium then available. The quick-drying action and color stability that the acrylic medium offered gave it a clear advantage over all other pictorial systems.

Joan Mitchell (1926), Forward Again III. *Private collection. The characteristics of acrylic paint allow for the creation of effects similar to those achieved with oils.*

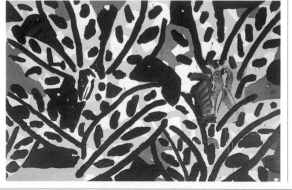

Aki Kuroda (1944), Messidor. *Peter Stuyvesant Foundation, Amsterdam. Acrylics allow for the use of flat colors and powerful graphics.*

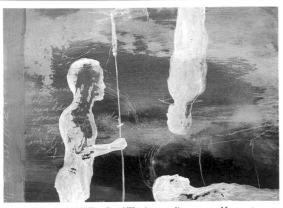

Ramón de Jesús (1965), The Good Warrior, *acrylic on paper. Margareta Linden Collection, Stockholm. Acrylics can be used to create singular effects, much like those achieved with graphic techniques.*

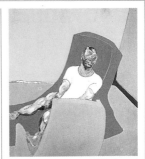

Francis Bacon (1918), Seated Figure. *Oil and acrylic on canvas. Private collection. Bacon's use of acrylics for the background and oils for the figure gives the work a great tonal quality.*

ing within a more or less self-imposed time.

Resins and Their Solubility

Acrylics are an ideal medium for painting because they're water soluble and malleable.

Advances in Technology

The introduction in recent years of new pictorial media by art suppliers led many artists on a search for new means of plastic expression, with acrylics soon becoming the most practiced form. Today, manufacturers of acrylic materials continue exploring new possibilities for the medium and have developed paints that produce a variety of finishes, are suitable for large mass application, have sponge-like qualities, and come in transparent or entirely opaque colors. They have also developed new translucent varnishes and additives that offer a wide range of possible textures.

MORE ON THE TOPIC

• Opaqueness and transparency of the medium **p. 8**
• Acrylics on the palette **p. 34**

Their resin base provides consistency, viscosity, and textural stability to the paint when it dries. Also, because it is entirely water-based, acrylic paint is easy to remove when wet.

The principal characteristic of the acrylic medium is that it is water-based, meaning that the paint can dry quickly through evaporation. While it is true that oils can produce shades of color not easily obtained with other media, the pictorially dense watercolor effects that can be achieved with acrylics make them a strong contender with traditional media.

Richard Estes (1932). Double Self-Portrait. *Acrylics can be used to produce works like this that resemble a photograph.*

A Versatile Medium

Acrylics are the most versatile of all painting media. They can be used in thin transparent layers and glazes to produce the effects of watercolors, or in thick opaque impastos to mimic the effects of oils.

While the plastic possibilities of acrylics seem to be endless, in the hands of a painter new to the technique they can present some problems, such as premature drying on the brush or in uncovered containers. However, once these problems are overcome, acrylics enable artists to work quickly, produce glazes and transparencies, and apply uniform coats of paint over large surface areas.

THE MEDIUM

OPAQUENESS AND TRANSPARENCY OF THE MEDIUM

The many possibilities offered by acrylics are due to the transparent and opaque qualities of the medium and to its water-solubility. The paints offer a wide range of chromatic and textural options thanks to the pigmented properties of the medium. There is a general misunderstanding about synthetic and vegetable paints (latex or rubber-based) which, though similar in appearance, have different origins and produce very different results.

What Is a Medium?

A medium is the base in which pigment is suspended or dissolved and to which pigment adheres so it can be applied to a surface. All paints are made up of a medium and pigment. The medium determines the painting technique; in other words, oil for oil painting, gum Arabic for watercolor or tempera, and acrylic for acrylic resin.

Quality and Transparency

As with all products, the quality of acrylic paint is closely related to its price. Sometimes, however, the brand of a product, rather than its quality, determines price; therefore, it is important to try different brands of medium on the same support (raw varnish or a colored base before being mixed with the pigment) to find out through identical stains (picture at top) which agent dries first and which is more transparent and pliable.

Samples of three different media before drying. The first stain, synthetic latex, is much more opaque than the acrylic stains to the right.

Acrylic paint dries to an elastic, compact film that can be applied to any porous support.

The same type of pigment can be used to make all kinds of paint. It's the medium that determines whether the paint is an acrylic, an oil, or a watercolor.

Technical Evolution in Plastic Arts
Opaqueness and Transparency of the Medium
Characteristics of the Medium

9

Color Purity

It is relatively easy to make acrylic paint, and many artists, in an effort to cut costs, do mix their own paints rather than buy them commercially. Don't be fooled, however—making good colors is not a simple task. Sometimes you need to have a good understanding of how the medium and pigment will interact in order to prevent your mixture from becoming too dark or from losing the tone you seek.

Acrylics come in brilliant, stable colors. The quality of the paint depends on the purity of the pigment and medium used.

Differences between Acrylic and Vinyl (Synthetic Latex) Mediums

Many beginning painters make the common mistake of confusing acrylic with latex paint. In its raw state, acrylic typically has an ammonia-like smell, a milky translucent consistency, and it dries to a highly transparent, colorfast finish. Vinyl, on the other hand, also known as *synthetic latex* is very thick, can be totally white, has a sweet, pleasant odor, and dries lighter.

The technical properties of latex and acrylic are similar in that both dry quickly to an elastic finish, but acrylic is the more durable and resilient of the two paints.

What Is Acrylic Paint?

Acrylic paint is a paint whose binder is a polymerized resin suspended in water. Polymerization is a chemical process whereby like molecules bind together to form a stable, transparent, elastic, and water-resistant film when the water in which they are suspended evaporates.

Acrylic stain.

Latex stain.

Dry stains of acrylic paint. After they dry, acrylics stay luminous and brilliant, retaining their texture and elasticity.

Highly textured effects can be achieved with acrylics, similar to those you can achieve with oils.

MORE ON THE TOPIC
- Characteristics of the medium **p. 10**
- Mixing colors **p. 30**
- Skin tones on the palette (colorism) **p. 32**

Acrylic and pigment molecules are suspended in a watery solution. As the water evaporates, the molecules come together in hexagonal structures that keep the pigment stable when evaporation is complete.

CHARACTERISTICS OF THE MEDIUM

Acrylics are the least known of all media available to beginning painters, perhaps because of the traditional role of oil as the best medium for painting. Nevertheless, acrylics measure up well against other media and have certain properties that give them a clear advantage over the rest.

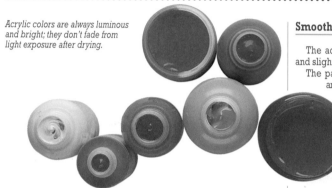

Acrylic colors are always luminous and bright; they don't fade from light exposure after drying.

Smooth Mixtures

The acrylic medium is milky and slightly viscous.

The paint is creamy and oily and can be easily mixed to produce different tones and colors. Acrylic mixtures are always smooth, and tones and colors mix and blend perfectly by gently stirring them.

Thick paints also mix easily, but require more vigorous stirring to avoid marbled effects or unwanted residues.

The smooth quality of acrylics allows one to paint completely flat colors, without any traces of color used in the mix.

Luminosity

Acrylic paint is luminous. This means that, being composed of a transparent polymer resin, the pigment enclosed in the acrylic medium receives and reflects light in all of its intensity after it dries; therefore, colors do not dry to an opaque state.

The luminous quality of acrylics allows a painter to obtain as wide a range of colors as those obtainable with other techniques.

Transparency and Density

Acrylic resin can be used on its own as a varnish that behaves just like paint after it is applied. When used as a varnish, acrylic is highly transparent, allowing pigment ranges from the totally transparent to the totally opaque to be added.

The medium can be made thicker, depending on the requirements of the artist. A transparent effect can be produced through the application of thin layers as well as thick impastos.

Completely transparent colors can be produced with the medium without it losing its density and body.

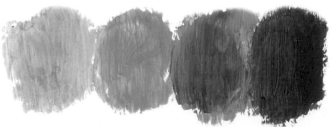

Mixed colors need to be stirred well with a brush to eliminate any trace of color used in the mix.

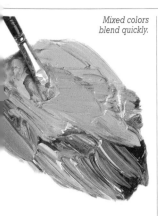

Mixed colors blend quickly.

volume. This means that thick daubs of paint will dry with the same stability as those applied with a fine brush.

Acrylic colors dry when the water in which the resin particles are suspended evaporates, at which time the particles bind to enclose the pigment. This chemical action causes the paint to contract, resulting in a slightly diminished brushstroke volume after the paint is dry.

Drying and Contracting

One of the characteristics of acrylics is that they dry in the same uniform quality regardless of pictorial

Sample showing how acrylic paint dries.

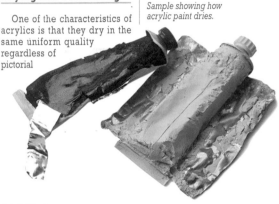

Color Chart

A color chart displays the colors a commercial brand has to offer. Each brand has its own color chart and similar colors may have different names depending on the manufacturer. You can determine the complexity of the colors of a particular brand by noting the variety of pigments and mixtures offered. Quality is extremely important when choosing acrylics. The color chart is a useful tool for artists because it shows basic as well as complex colors. By displaying the tones and colors that are available commercially, the chart makes it unnecessary for a painter to have to develop them on the palette.

Lightfastness

A problem common to pictorial media is that color exposed to light tends to fade over time. Even though all painting media are affected by this problem, oils and acrylics are the least likely to undergo chromatic deterioration. The acrylic medium itself protects the pigment enclosed within it.

The acrylic medium protects against chromatic deterioration caused by exposure to light.

MORE ON THE TOPIC

• Opaqueness and transparency of the medium **p. 8**
• Mixing colors **p. 30**

MAKING ACRYLIC PAINT

Acrylic colors are relatively easy to make compared with the complex formulations required for oil or glue-based paints, however, great care must be taken when preparing acrylics if a quality product is to be achieved. As a general rule, artists should know how to make their own paints, but this does not preclude mixing the paints they make at home with commercial ones. Some of the latter should be kept on hand for use in the complex mixing process needed for specific tones.

Different commercial presentations of a quality acrylic medium used in making color.

Mediums Needed

Basic materials are needed to carry out any artistic activity; otherwise, it would be impossible to do the work.

While acrylic paints are easy to make, it is important to have all of the materials ready before you begin. First you'll need medium, which, as you'll see, comes in different sizes but is always less expensive to buy in large containers. You'll also need pigment, which is available in jars but less expensive to buy in bulk, particularly earth tones, whites, and blacks.

Matte or Gloss Paint

Before you begin to prepare the paint, it's a good idea to know what kind of medium you'll be using. In other words, will your final product have a flat or a shiny finish when dry?

Acrylics are available in satin finish, but can be made more or less glossy depending on the medium you use.

Most manufacturers provide semigloss mediums, but, if you're interested in a matte finish, there are several brands of acrylic varnish on the market with this characteristic.

Materials needed to make paints.

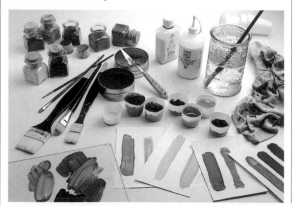

1

2

The first stain (1) was made with a gloss medium, the second (2) with a matte medium.

Color Mixing and Testing

Preparation of the paint begins by putting the amount of liquid medium you need into a mixing container.

Keep in mind when mixing in the pigment that the volume of the paint will be determined by the amount of liquid you add, not by the amount of pigment.

Use a palette knife or a spoon to add the pigment to the acrylic medium. Measure carefully and remember that it's always better to have to add more pigment than more acrylic liquid.

Stir the mixture using circular brushstrokes, scraping pigment from the sides of the container and breaking up any lumps that form on the bottom.

1 2 3 4

The shiniest stain (1) has bubbles because of too much acrylic medium in the mixture; the second stain (2) has loose pigment because of too much pigment in the mixture; the third stain (3) has just the right amount of pigment and acrylic; the last stain (4) was made with a paint that does not have enough pigment.

Problems and Solutions

Grainy paint and loose pigment after the paint dries means that there's either too much pigment in the mix or that is wasn't stirred enough. Paint still leaching back into the support after the paint surface dries indicates a defective drying agent or a medium that doesn't have enough water. Tiny holes on the surface of dry paint mean that foam was created during stirring, a problem that can be prevented by using a completely dry brush to mix the ingredients or an agent to stabilize the mixture.

MORE ON THE TOPIC

- Characteristics of the medium **p. 10**
- Thick paste (gel), varnishes, and additives **p. 16**
- Priming for acrylic painting **p. 26**

Testing Different Brands

It's important not to limit yourself to only one kind of acrylic medium. Instead, you should look for different makes and manufacturers and compare, experiment, and record the results of the mixtures made with the various products. Experimentation will, in the long run, become one more tool for you to use.

Pour the necessary quantity of medium into the mixing container.

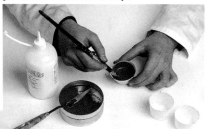

Use a palette knife to add the necessary pigment.

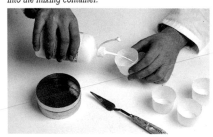

Continue stirring with the brush until you get a smooth mixture without lumps.

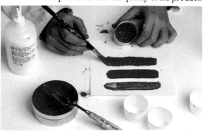

Depending on how you make the paint, it's important to test the quality of the product.

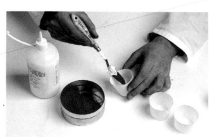

COMMERCIAL PRESENTATIONS

As with other paints, acrylic paints can also be made at home, however, you'll need a variety of raw materials, such as an acrylic medium and pigment. Manufactured products come in containers that always indicate characteristics of the medium or varnish on the label. Acrylic paints also come ready-made. Because some colors are more watery than others, product information on consistency and application is generally given on the label. Painters should select their products carefully based on the kind of work they're going to do.

The Medium

The medium serves two basic purposes: First, it is used to make the paints themselves; second, it is used as an additive to dilute ready-made paints without loss of their principal characteristics (shine, elasticity, and adhesion).

Several commercial brands of the medium come in small glass jars, which are especially convenient for artists who use the medium as a paint dilutant when working on small jobs.

Other brands of the medium come in 8-ounce, 16-ounce, 32-ounce, and gallon containers. It's always cheaper to buy your medium in large containers than in small jars.

There are several high-quality brands available on the market.

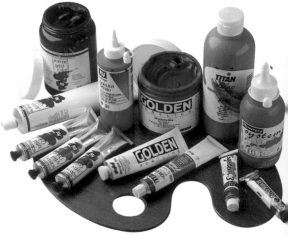

Art suppliers provide a wide variety of jars and tubes to satisfy the requirements of any painter.

Varieties and Characteristics

Manufactured acrylics come in a variety of sizes, with different characteristics to suit the needs of individual painters.

It's important to choose carefully when buying paint because the type of container you select will partly determine how your work turns out. For example, if you're planning to do detailed, minute work, you probably won't need large containers of paint. On the other hand, if you're going to work on a large area, you'll find it inconvenient to work with small tubes of paint.

Quality is important when choosing a medium. The quality of a product is determined by its smoothness, transparency after drying, elastic properties, drying time, and ability to absorb pigment.

Acrylic Tubes

The most traditional way to buy acrylics is in tubes that have screw-on tops. Manufacturers sell acrylic tubes of paint in a variety of sizes because many artists prefer to work with the paint in tubes.

Working with acrylics in tubes is the best way to control the amount of paint you use. Bear in mind that tubes are practical only if the format you're working on warrants their use. For example, tubes are not practical if you're working on a large area because you'll quickly run out of paint. On the other hand, it's always a good idea to have several tubes of expensive paint available for special needs.

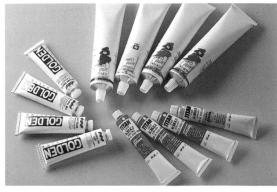

Acrylic tubes of paint, though highly practical, can be rather restricting when working on a large area. Designed mainly for easel work and open-air painting, tubes come in a variety of special colors that make them an attractive investment for many artists.

Acrylic tubes allow a painter to work outdoors and to paint from nature. They are sold in boxes of assorted colors.

Acrylic Jars

Many artists need acrylic paints in quantities that are not available in screw-top tubes. These artists can purchase their paint in jars that come in a variety of sizes, some of which have wide mouths that make access to the paint with a palette knife or brush quite easy; others have cone-shaped openings or small holes through which the paint comes out. The jars with small openings are ideal for all users because, if the jar is accidentally left open, the paint won't dry up so easily.

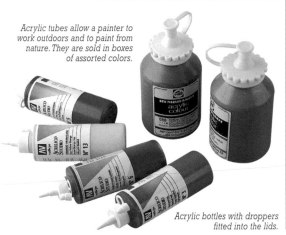

Acrylic bottles with droppers fitted into the lids.

MORE ON THE TOPIC

• Characteristics of the medium **p. 10**

• Thick paste (gel), varnishes, and additives **p. 16**

• Priming for acrylic painting **p. 26**

Using the Right Amount

One of the most valuable characteristics of the acrylic medium is its fast drying time. This feature will, at one time or another, exasperate almost any artist, so, you should be very careful about the amount of acrylic you put on your palette. If you put too much, you may waste it at the end of a painting session unless you return it to a wide-mouth jar with a cover. On the other hand, if you put too little paint on your palette, it will probably dry up due to lack of water unless you apply it quickly.

Using just the right amount of paint on the palette will help prevent the paint from drying up or being wasted at the end of a painting session.

Wide-mouth jars of acrylics.

THICK PASTE (GEL), VARNISHES, AND ADDITIVES

Gels are used to enhance the elasticity of the acrylic medium and adjust its consistency for special effects, such as glazing or impasto, or to make the paint glossier or more matte. In addition to gels, other products can also be added to acrylics to produce different effects. Use of these products is not essential because the paints you prepare, as well as those you buy commercially are ready for use. However, it's a good idea to know what these products are and to use them whenever you want to create new effects in a medium rich in plastic possibilities.

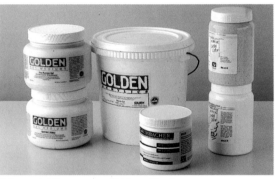

Gels come in thin, average, and thick consistencies. Characteristics for each are indicated on the label.

Texture paste will allow you to work on rough surfaces or to produce graphics like this one.

Gel

Acrylic paints contract as they dry. Some artists find this aesthetically unappealing and prefer to use a thicker paint with body that does not undergo this process. By adding gel to the paint, you prevent it from contracting and help it hold a stable volume. The paint will also dry to a finish that is similar to the one you get with oil.

Thick Texture Paste

Thick texture paste is a gel medium containing a substance that gives it texture. Artists use this additive when they want to give a particular texture to the surface of a painting, either by applying the medium as a base coat or by mixing it with paint. Because the gel has no pigment, it can be mixed with any color without changing the color's tone. Among the substances most often mixed with the gel are washed sand and marble or alabaster dust. Also used are granulated products that give a uniform texture to the whole surface.

The Medium as a Base Material

The acrylic medium serves as a base for additives and paint components. While many mediums are available today, it is more interesting to explore the pictorial possibilities of the medium without always resorting to the use of commercial products. Adding a few drops of ammonia, alcohol, or glycerin to the medium provides the artist with a choice of effects in paint finishes. Experimentation should always be part of the experience of a plastic artist.

Adding gel gives acrylics the texture of oil paints without the loss of its own advantages.

The acrylic medium is the basis for all the plastic possibilities of acrylics. Experiment with the medium by adding sand, earth, or other additives to it.

Commercial Presentations
Thick Paste (Gel), Varnishes, and Additives
Brushes. Types and Characteristics

17

Retarders

The different consistencies of acrylic paint allow artists to work under any condition, both inside and outside the studio. However, the medium's most valuable attribute—its quick drying time—can become a major inconvenience for the artist who needs more time to manipulate the paint or who works in warm conditions that accelerate drying. A special additive, called a retarder, can be added to the medium or paint to slow down the paint's drying time and keep it workable. It's not a good idea, however, to rely too heavily on retarder additives because they may change the characteristics of the medium.

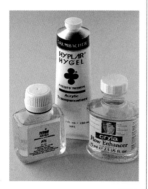

Flow Improvers

Even though acrylic is a water-based medium, you should not add more water to the medium because this might break down the acrylic resin in suspension. It is always better to dilute an acrylic medium with an additive designed specifically for that purpose.

Transparency Enhancers

A transparency enhancer is an additive that can be mixed with the acrylic to improve the transparency of the paint. The additive, an acrylic gel that acts like a medium, allows for greater spreadability of the paint while maintaining its consistency and elasticity. Because it is transparent, small quantities of color can be added to the additive for use in glaze and wash techniques.

Flow improvers, transparency enhancer and retarders are all additives that change the properties of acrylic paints, giving them new technical characteristics.

MORE ON THE TOPIC

- Characteristics of the medium **p. 10**
- Priming for acrylic painting **p. 26**

The transparency enhancer makes the paint less opaque without altering its density.

Varnishes

Like oils, acrylics dry to a shiny, freshly-painted look. However, unlike oils, some colors can remain slightly sticky to the touch. This can be prevented by using any one of the several commercially available varnishes. Some varnishes will allow you to superimpose layers of color on top of each other without the layers degrading over time, an essential feature for keeping a painting in good condition. Other varnishes cannot be used with layers of color and serve only to protect the surface of the painting from dust and degradation.

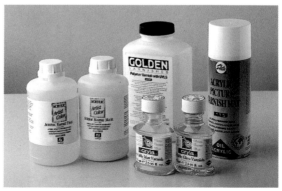

Application of an acrylic flow improver to an acrylic paint stain. The stain at the right was made after the additive was mixed with the paint.

Many varnishes can be painted over, but their real purpose is to suppress the leaching action of the paint and protect the pictorial surface from dust.

BRUSHES. TYPES AND CHARACTERISTICS

Acrylics are adaptable to a wide variety of painting techniques. They can mimic the appearance of watercolors when used transparently and in glazes, and oils when applied in thick textured layers of color. Acrylics are also capable of doing what other media cannot, such as producing totally transparent impasto effects. Each of these treatments requires different kinds of brushes and procedures.

Parts of the Brush

Brushes consist of three different parts: handle, ferrule, and hair bundle. Making a brush is a delicate process, particularly when it comes to selecting the fiber and the shape it will take. It is important to remember that a coat of quality chromium paint on the ferrule will keep it from corroding, especially necessary for brushes used in acrylics that are always in contact with water. Also, a coat of varnish or lacquer on the brush's handle will protect the wood from rotting.

MORE ON THE TOPIC
• Easels and paint boxes **p. 20**

Hogshair Brushes

Hogshair brushes, also known as bristle hair brushes, are the most widely used and economical. Their slightly textured hair—as opposed to entirely smooth—allows them to carry a lot of paint and their split tip enables them to produce smooth lines. Also, their stiff, pliable bristles and bifurcated tip allow them to absorb and spread large quantities of paint smoothly and evenly on the canvas.

Hogshair brushes are hard and pliable. They carry a lot of paint and leave a hair trail.

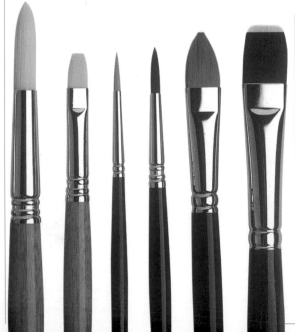

Synthetic Brushes

Synthetic brushes are also commonly used in acrylic painting. Made with top-quality imitation hairs, the brushes have undergone remarkable improvements over the years. Several of the better synthetic brushes have great absorbing power, allowing for long and smooth brushstrokes. However, unlike hogshair or other natural types, the bristles of synthetic brushes are entirely smooth, which does not pose a problem for acrylics, particularly when working with thick paint. Synthetic brushes are highly durable if properly cared for and are the types of brushes most recommended for acrylics.

Synthetic brushes are used to create smooth backgrounds. Generally soft and pliable, they are available in different qualities.

Thick Paste (Gel), Varnishes, and Additives
Brushes. Types and Characteristics
Easels and Paint Boxes

19

Flat Brushes

Flat brushes are the favorite of many artists. Their hair bundles are as long as the ferrule itself, and flat rather than round, which makes mounting the bundle as an extension of the ferrule much easier. Flats are larger than other brushes, making them very useful for covering large areas and painting backgrounds and tonal gradations with maximum precision.

Flat brushes carry a large amount of paint but, depending on their quality, are still capable of producing detailed brushwork.

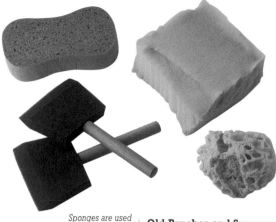

Sponges are used to spread color evenly and to create texture and dragging effects.

Old Brushes and Sponges

Brushes wear out with use, but this does not mean you should throw them away. On the contrary, old brushes are often valuable tools that serve a variety of purposes. For example, they draw irregular lines, which makes them ideal for creating different textures, superimposing layers of color and glazing.

Sponges are also important in acrylic painting and can be used to apply large masses of color quickly without leaving marks. Sponge rollers are also useful for texture work and can be either rolled or dragged across a painting, or pressed onto its surface to make an imprint.

Flat Chinese hogshair brushes can hold a lot of paint. With soft and smooth bristles, they are highly suitable for creating graphic effects.

Flats are the most popular brushes. They can be used for painting large areas, applying smooth backgrounds of color without visible line breaks, and creating an infinite number of lines and textures.

Caring for Brushes

During a painting session, you should always keep the brushes you are not using immersed in water. This will keep them from drying and wearing out.

At the end of the session, rinse all brushes in clean water to remove excess paint. Then wash them with soap from the ferrule to the tip and dry them with a clean rag.

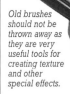

Water is the best ally of brushes when it comes to their care. Always keep the brushes you are not using immersed in water to keep them free of excess paint, and wash them at the end of the session.

Old brushes should not be thrown away as they are very useful tools for creating texture and other special effects.

SUPPORTS, MATERIALS, AND EQUIPMENT

EASELS AND PAINT BOXES

The basic materials you need for working in acrylics are a support, paint, and brushes, but to work comfortably, you'll need other items as well, such as an easel for holding your painting while you work and a box for organizing, carrying, and storing paint supplies. Paint boxes come in several models and qualities and are sold fully equipped or empty, depending on how much you want to spend. You don't have to buy the best or most expensive model; paint boxes in the mid-quality range and price are more than suitable for the beginning painter.

Studio Easels

Easels are essential tools for most painters because they immobilize a canvas while a painter works on it.

Easels can be made of wood or metal, can be adjusted for height, and come with ratchets that hold the canvas firmly in place.

Studio easels have extensions that allow them to accommodate large paintings and do not usually fold up.

Several folding easels are available, however, and, though not as stable as fixed easels, they're practical in that they take up very little room.

Tabletop Easels

Tabletop easels are small and require little space. They're mostly designed for small-scale work and can be used on a table or desk.

Some tabletop easels are equipped with a tilt that allows the painter to always work in a comfortable position with respect to the canvas.

Folding studio easel.

Fixed studio easel.

Different tabletop easels.

Brushes. Types and Characteristics
Easels and Paint Boxes
Supports. Canvas

21

Several outdoor easels. All of these easels come with ratchets for holding the painting in place.

Paint Boxes

Paint boxes are ideal for artists who already have all the painting materials they need and who simply want to change their old box or add a personal touch to it by mixing favorite makes and types of acrylics paints.

Two boxes of assorted acrylic paints.

Folding or Outdoor Easels

Folding easels are equipped with metal rods used to extend the easel. These types of easels are lightweight and generally not very stable; however, since they are largely designed to hold small paintings, stability is not usually an issue.

There are many types of outdoor or folding easels on the market and the least expensive ones do not always produce good results. Because an easel is something you can expect to have for a long time, it is worth spending a little more to invest in a good one.

Box Easels

A box easel is a practical wooden suitcase in which you can fit all of the items you need for painting comfortably with acrylics. The French model comes equipped with a tripod and a drawer that comfortably holds paints, palette, and canvas, making it very useful for outdoor painting. Easels without a tripod are just as practical but need to be set up against a sturdy support.

The Best Easel

When buying a studio easel, it is best to buy one with wheels. If you need a folding one, check to make sure it is sturdy when mounted and has the necessary ratchets at the top and bottom to hold your work securely in place.

Boxes of Assorted Acrylics

Several suppliers manufacture boxes of assorted acrylic paints in a variety of colors. The paints and brushes that come in the boxes are segmented into different compartments.

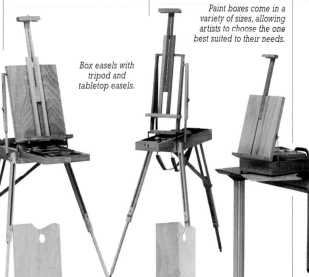

Paint boxes come in a variety of sizes, allowing artists to choose the one best suited to their needs.

Box easels with tripod and tabletop easels.

MORE ON THE TOPIC
• Brushes. types and characteristics **p. 18**

SUPPORTS, MATERIALS, AND EQUIPMENT

SUPPORTS. CANVAS

The support for acrylic painting can be any non-oily and, if possible, porous surface.
Acrylic can be applied to primed or unprimed canvas, paper, wood, or
cardboard. The results obtained when using one of these supports
depend on how absorbent or thick the paint is.

Unprimed Canvases

Natural fibers are clearly visible on unprimed canvases, which are sold untreated so that artists can prime them according to their own preference.

Canvas is the lightest and most resistant of all the supports available. Made up of interwoven fibers, canvas can be used for many purposes according to its weave—the more taut the threads, the tighter the canvas; the thicker the threads, the thicker the canvas.

Different vegetable fibers, cotton, linen, or hemp can be used in weaving a canvas. Linen canvases are generally of better quality and are the best for applying acrylic primers.

Cotton canvases don't have the same quality as linen canvases; however, once primed, they provide an excellent surface for painting. Because of their affordable prices, they are recommended for beginning painters. Cotton (1). Linen (2).

1

Primed Canvases

Priming acts to prevent the support from coming into direct contact with the paint, thereby reducing the amount of paint absorbed. Canvases come already primed with either a thick, textured, or fine primer. The kind you buy will depend on the type of work you plan to do. When using acrylics, it is always wise to consult with a knowledgeable salesperson about the kind of priming you would need for your particular project. Acrylic gesso, plastic, or rabbitskin glue are common primers. Acrylic and plastic primers are most pliable and stable because they don't break down with age.

Acrylic priming is most frequently recommended because it eliminates problems with tension on the stretcher and gives the cloth an elastic quality, important features for high-quality cotton and linen canvases. Paint samples on linen (A), cotton (B), and burlap (C).

2

A

B

C

Easels and Paint Boxes
Supports. Canvas
Rigid Supports and Paper

23

Grain

Canvases come in fine, average, or thick grain. The type of canvas you choose will depend on the work you're planning to do. If you're going to do detail painting, then you'll probably want a canvas with a fine grain. If you're planning to do a freer, more expressive type of work, you'll need a canvas with average or thick grain.

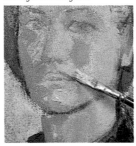

The Best Canvas for the Job

While the best canvases are made of linen, these may be a little too costly for the beginning painter. A good substitute would be a top-quality cotton canvas. Canvases made from a blend of synthetic fibers, cotton, and linen are also suitable.

There are two ways to buy canvas: mounted on a stretcher or unmounted off the roll.

Canvas bought in bulk or by the yard comes primed or unprimed, depending on the requirements of each artist.

Cotton and Linen

There are different types of flexible canvases available. The quality of a canvas depends on how it is woven and primed. Some canvases are made and woven with very fine cotton and have a homogeneous surface; they come in fine grains and smooth textures. Most artists use canvases of average thickness because they're adaptable to a variety of purposes. Cotton canvas made from thicker thread is also known as sailcloth. Linen canvases are the most durable of all the fiber canvases available.

Quality and Price

There are several reasonably priced and fair-quality canvases available for beginner painters. Sailcloths that have been treated with a thick acrylic priming agent are available for the more serious painter, but because of their professional quality, these canvases are also more expensive. Cheap canvases do not produce good results, even for beginners. It's wise, to pay a little more and buy a canvas that is at least at the lower end of the professional line.

> **MORE ON THE TOPIC**
>
> - Thick paste (gel), varnishes, and additives **p. 16**
> - Rigid supports and paper **p. 24**
> - Priming for acrylic painting **p. 26**

A comparison in the textures of raw linen (at left) and cotton (at right) canvases.

It's less expensive to buy canvas by the yard than mounted on a stretcher.

RIGID SUPPORTS AND PAPER

Acrylic medium can be applied to any type of rigid support as long as it has been adequately primed for controlling the paint's moisture. Among the many hard supports available for use with acrylics, the most common are wood boards, particleboard, cardboard, and Masonite. Paper is another ideal support for acrylics; and it does not need priming because the medium itself acts like a primer.

Woods

Wood is a good support for acrylic as long as it has been primed with an acrylic medium, latex, or gesso.

Wood was used as a pictorial support long before canvas. Solid wood is generally no longer used because of its susceptibility to

Fabric-covered cardboard canvases fall somewhere between flexible and rigid supports.

cracks, decay, and warping. Instead, particleboard and plywood in varying degrees of thickness are used. These are more resistant and stable and can be bought in a hardware or art supply store.

Wood panels, industrial cardboard, white cardboard, and paper are good supports for acrylic paint.

> ### MORE ON THE TOPIC
> • Thick paste (gel), varnishes, and additives **p. 16**
> • Supports. canvas **p. 22**
> • Priming for acrylic painting **p. 26**

Particleboard and Plywood

Particleboards are made of glued and pressed wood shavings and come in different thicknesses, from $1/4$ inch to 2 inches. Though resistant to expansion and contraction, the boards are susceptible to moisture and can become damaged if wet; therefore, it is important to properly prime the boards. They are sold bare or lined with canvas.

Plywood is an ideal painting support, impervious to bending and changes in temperature. It consists of several layers of wood glued together with the grain of plies at right angles to each other. This structure greatly enhances the strength of the board, some of which have thicker cores and are finely laminated.

Stain on particleboard primed with gesso.

Stain on plywood primed with latex.

Supports. Canvas
Rigid Supports and Paper
Priming for Acrylic Painting

25

Cardboard and Paper

Cardboard and paper are two of the most frequently used acrylic supports, which, when properly primed, do not absorb wet paint. However, priming is not always required because the paint itself acts in many cases like a primer.

Thick pieces of cardboard are better suited for acrylics than thin ones, but are more difficult to handle. Since moisture causes twisting, it is best to fix the cardboard to a rigid surface with either nails or staples before applying a coat of primer or paint.

Heavyweight paper, ideal for acrylic paint.

Canvas paper has been imprinted with the texture of canvas but still retains the qualities of paper.

Unprimed industrial cardboard.

Stretchers

Stretchers are useful for stabilizing flexible supports such as canvas or paper and for enhancing the stability of rigid supports such as cardboard and wood. Stretchers come in regular or heavyweight size. Large canvases require a heavyweight canvas; otherwise a regular weight will do.

Stretchers are generally mitered with an extension that enables one to fit into the other. Most stretchers can be easily disjointed.

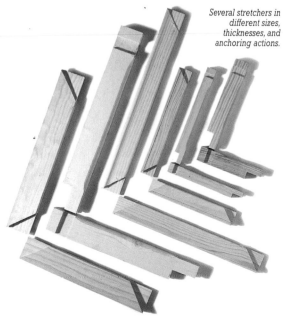

Several stretchers in different sizes, thicknesses, and anchoring actions.

Paper, Acrylic, and the Art Shows

Acrylic is a relatively new medium, but, over the last few years it has become the medium most frequently used by contemporary artists, particularly because of the art shows that are held each year. These large group exhibitions display paintings done on paper by important contemporary artists. The purpose of the shows, whose idea came from the dealer Jean-Pierre Gillemot, is to sell original works at affordable prices

PRIMING FOR ACRYLIC PAINTING

Priming is a layer that reduces the absorbency of the support so that the paint does not lose its liquid components. Acrylics can be applied directly to any support, with the amount of paint absorbed depending on how porous the support is. Thus, different types of supports will need a primer to seal their surface and make painting easier. To do this, several priming systems are available, depending on whether you're using a canvas, wood, or cardboard support.

Acrylic medium can be mixed with loads such as whiting or precipitated chalk to create a completely smooth surface.

Priming a Canvas

Primings for canvas should preserve the elasticity of the support and, at the same time, seal it. The main priming agents for canvas are latex, gesso, and acrylic priming.

Latex and acrylic medium are resinous varnishes that dry to a shiny elastic finish. If you're going to use one of these sealers, we recommend that you first mount the canvas on a stretcher.

milky consistency so that it penetrates the fibers completely. The mixture is then applied with a flat brush, spreading it across the canvas in one direction until the canvas is completely covered and saturated. After the first layer dries, a second coat is applied in the opposite direction. Finally, a thicker coat with white zinc or another color added is applied lengthwise.

The initial priming should be prepared to a runny, creamy consistency so that it can thoroughly penetrate the fibers of the canvas.

Priming with Gesso

Commercial acrylic gesso provides good coverage and is very thick, making it easy to seal the pores of the canvas.

Gesso is applied to a canvas using a wide, flat brush to cover the pores and weave completely. Like acrylic and latex, gesso should be applied in several layers, with a final layer of light passes to smooth out the surface.

MORE ON THE TOPIC
- Characteristics of the medium **p. 10**
- Making acrylic paint **p. 12**
- Thick paste (gel), varnishes, and additives **p. 16**
- Supports. canvas **p. 22**
- Rigid supports and paper **p. 24**

Different brands of acrylic gesso.

Latex is a good priming medium to use for priming as long as it is a quality brand.

Procedure

A canvas can be primed with an acrylic or latex formula, thinning the medium beforehand to a

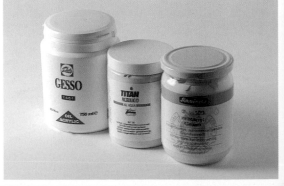

Priming Rigid Supports— Cardboard and Wood

Rigid supports may need only one priming, depending on their use.

The best rigid supports are those that are more resistant to the effects of moisture, such as plywood and Masonite. Plywood is made up of several layers of wood glued together with the grain of plies at right angles to each other. It is especially resistant to warping caused by humidity and is primed in a more uniform fashion than cardboard. Masonite is completely smooth and easy to prime.

Latex makes priming any porous support such as wood easy.

Modeling paste provides texture to any type of support.

Priming with a base white will allow you to completely cover the texture of the grain in the wood and the pores in the cardboard.

Gesso should be applied across the canvas, paper, or wood in several crisscrossed layers.

After it is completely dry, you can sand the surface with a fine sandpaper to clean it.

Emergency Priming

There's a rather simple and relatively effective way to prime cardboard, wood, and paper that will be used for small notes and quick acrylic sketches: Rub a clove of garlic on the surface of the pictorial support to seal its pores. (The only problem with this method is the smell of garlic that stays on your fingers!)

PALETTES AND MIXING METHODS

Acrylics can be either thick and pasty or completely liquid, depending on their use. This versatility makes it logical to assume that acrylic mixtures will need to be carried out on different kinds of palettes according to the form in which they are being handled.

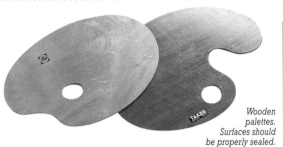

Wooden palettes. Surfaces should be properly sealed.

Wooden Palettes

Wooden palettes are especially indicated for acrylic paint that has a pasty consistency and will be used undiluted in thick applications and when using a palette knife.

The palette should be properly treated so that the paint's moisture does not seep into the pores of the wood. Treatment consists of applying a few layers of varnish to the palette, though most palettes have already been varnished when you buy them. It is also easy to make your own wooden palette: Cut out a rectangle of wood, smooth its edges with sandpaper, and varnish it on both sides.

Plastic and Paper Palettes

Plastic palettes are the best for acrylics because of their smooth, nonporous surfaces that prevent paint from becoming encrusted on them and that allow both wet and dry paint to be removed easily. Plastic palettes come in a variety of shapes, ranging from the traditionally shaped ones to those that are completely round and have small wells for holding watery paints.

Plastic palettes are quick and easy to clean.

If the palette is not sealed, apply a few coats of varnish to it.

Dishes make ideal palettes for mixing acrylics.

Several disposable paper palettes.

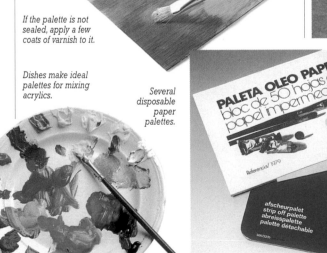

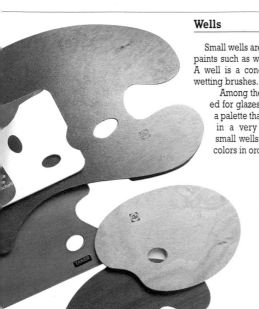

Wells

Small wells are particularly useful when working with liquid paints such as watercolors or with oils and acrylic mediums. A well is a concave receptacle used for mixing paint and wetting brushes.

Among their other uses, acrylics are especially indicated for glazes and color washes. These techniques require a palette that will allow you to keep the paint and medium in a very liquid state. Some palettes have built-in small wells laid out in a circle so you can arrange your colors in order.

A painter should become familiar with the huge variety of palettes available before choosing one.

Cleaning the Palette

After each work session, the palette should be thoroughly cleaned to prevent any buildup of paint that might interfere with later paint mixing. The easiest way to clean the palette is with water before the paint dries. After it has dried, you can scrape it off with a knife or scraper.

Containers

When working with acrylics, you'll need a variety of all-purpose containers for mixing colors, holding water, rinsing brushes, or applying uniform washes of color.

Any type of container can be used in acrylic painting except glass, which might break. Plastic containers are easy to clean, even when thick layers of paint have dried on them. In this case, the paint can be pried loose from the sides and pulled away.

MORE ON THE TOPIC
• Brushes. types and characteristics **p. 18**
• Mixing colors **p. 30**
• Acrylics on the palette **p. 34**

Thick crusts of paint must be removed with sandpaper if they cannot be removed with a scraper.

Wells can be incorporated into the palette. This is the best way to work with liquid acrylics.

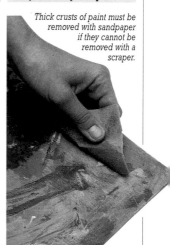

TECHNIQUE AND PRACTICE

MIXING COLORS

Acrylic paint is developed in a medium of watery resin. This characteristic allows pigment to dissolve easily in the medium, more so than it does in other media such as oil. Acrylic colors also mix easily with each other. When acrylic resin dries, it traps within its structure any particles that are suspended in the medium.

Suspension of Pigment

Pigment is easily taken up by the acrylic medium, making the mixing of pigment, medium, and ready-made paints relatively easy. In any event, when the pigment that is going to be used is moistened beforehand, any manipulation of it, whether it be mixing it with raw medium or directly with paint, will have a smoother and more homogeneous result.

To moisten pigment, simply spray a few drops of water on a quantity about the size of a walnut; the mixture should be stirred until it reaches the consistency of thick paste. As you will see, the pigment lessens considerably in volume after water is added.

Dry Mixtures

Dry pigment can be mixed directly with acrylic medium in order to compare the color variations between dry and wet pigment. Dry colors always change after being moistened, and then slightly again when they dry, though good-quality varnishes are available that ensure color stability.

Any color can be shaded with pigments of warm or cool colors.

Shading the Tone of a Dry Mix

When you have found the approximate tone based on the mixture of two or three colors, you can approximate a certain chromatic tendency by adding more

or less quantities of other colors. The addition of titanium white will lighten any color; small quantities of red will produce warm colors; and blues and greens will turn warm colors into earth tones or cool colors if you increase their proportion.

Three colors in pigment form are easily dry-mixed with the medium— two main colors to find the base tone and a third color to adjust it.

Pigment can be lightly moistened with an atomizer. Moistened pigment binds better with the acrylic medium.

Dense Mixtures and Tonal Adjustments

Colors are much easier to mix when the paint is already prepared; tones can be adjusted more easily than they could if you are starting with dry pigment color.

One color can be mixed with another by simply adding small quantities of the second color until you obtain the desired tone.

You should not use the same amount of paint for obtaining tone as you do for mixing colors. The tone of a mixture can be changed by adding a small quantity of a third color, varying the tone slightly within its chromatic range; additions for tonal adjustments will be very small.

If, when mixing red with dark blue, you get a violet that's too dark, lighten the mixture with light violet, not with white.

Lightening a Color

It is not unusual for a color to get darker while it is being mixed with other colors and to get increasingly further away from the tone you're seeking. Beginning painters often solve this problem by adding white to lighten the tone. This is a big mistake, because even though white does lighten color, it also reduces the color and dulls it. It is always best to use light colors from the same chromatic range to produce lively, luminous tones.

Adding a small amount of black to blue will change the tone of the blue.

Warning Against Inhaling

Pigment is a very fine-colored powder whose particles sometimes remain suspended in the air, so it is important to take great care to avoid inhaling the pigment. This can be done by covering your nose and mouth with a handkerchief or mask while you work.

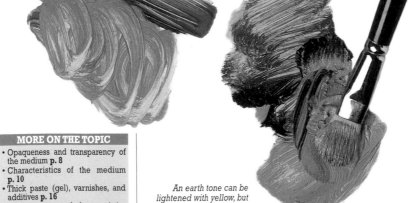

An earth tone can be lightened with yellow, but keep in mind that yellow tends to make a tone cool.

SKIN TONES ON THE PALETTE (COLORISM)

The study of color theory can be based on different subjects, but the study of flesh tones or skin color is the best way to understand that color is determined by the light that shines on an object and not by the object itself. The lighter the surface area of an object, the more light it reflects; the darker the surface area, the more light it absorbs.

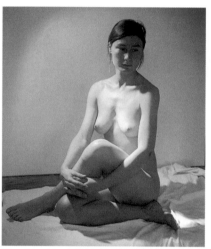

The subject is positioned before two different focal points of light. The skin, which depends solely on the focus of the light that illuminates it, is completely different in color and tone.

Unreal Color

The color of an object is determined by the light that illuminates it. This theory was developed by the Impressionists during the last decades of the nineteenth century. If you apply the colorist theory to skin, you'll see that color depends on where the model is situated. For example, if the subject is seated in front of a window or before a focal point of yellow light (Such as a light bulb), skin tone will be different and may even be tinged with highly unusual tones.

Warm and cool colors come equally into play in the portrayal of flesh tones, each range contributing its own luminous possibilities.

Possibilities of the Medium

Acrylic medium offers the possibility of painting with either opaque or transparent colors. This characteristic gives acrylics great plastic possibilities when carrying out a chromatic search on both the palette and painting. All colors, warm and cool, participate in skin tone and are determined by the light. Blue tones produce a chromatic range of violet when mixed with crimsons and reds, and a green chromatic the more they approximate yellow tones. On the other hand, when mixed with red tones, greens become earthy tones or oxides.

| MORE ON THE TOPIC |

- Palettes and mixing methods p. 28
- Mixing colors p. 30
- Acrylics on the palette p. 34
- Painting skin tones p. 38

Mixing Colors
Skin Tones on the Palette
Acrylics on the Palette

33

The Search on the Palette

If you begin with a specific color as a chromatic base for rendering a skin tone, use the palette to approximate the color of the model, making chromatic additions to the base color to make it a cool or warm tone. Add red, yellow, or blue tones to this color and place your conclusions next to each other so you can compare the simultaneous contrasts produced by the colors.

Mixtures on the palette should be done comparatively, by matching the base color with the tones that are obtained.

Mixture of warm tones without the use of white.

Testing Tonal Quality with and without White

Different tones will emerge from the comparisons you made on the palette. Starting with two colors and white will produce different results of light and tone, depending on how much of each color you add.

Though white tends to subdue the mixture, its use should not be rejected. To the contrary, a skillful use of white in contrast with other pure colors will result in great luminosity and chromatic richness.

Crimson, ochre, and white will produce a possible flesh-colored tint whose tonal quality will change depending on how much of each color is used in the mixture.

Tonal quality varies when more crimson and ochre are added to white.

Depicting Light

You don't paint flesh; what you paint is the color of the light the skin reflects. Therefore, as a general rule, you should not avoid using any particular color, but you should make good use of the colors within the correct chromatic range. One way to clarify this concept for yourself is to paint the same figure using two different chromatic ranges, for example, using only blue tones or red tones.

Making the Unreal Real

When painting tries to capture reality, it does so by always comparing some colors with others. In other words, a color appears real in a painting to the extent that its adjoining colors make it so. Therefore, one can establish any real chromatic range for a subject by establishing on the palette colors that have the same relationship between them as those of the model, regardless of whether their chromatic value is similar to that of the real subject.

ACRYLICS ON THE PALETTE

Acrylic colors allow artists to work more freely than they might with any other pictorial media because when acrylics dry they do so evenly, without problems in cracking or similar defects that beset other systems when improperly handled. Even though they present few problems, however, acrylics require a certain skill in handling, particularly with respect to their quick drying, not so much on the canvas but in the colors being used on the palette. Therefore, the amount and color of paint from the selected chromatic range that you should have on your palette should be based on how and when you are going to use it.

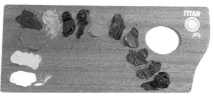

Colors arranged by tone.

Colors arranged harmoniously.

Search and Discover

Any tone or color present in the model can be found through a chromatic search on the palette. As you develop your search for a specific color, always try to use the least amount of paint possible. One brushstroke for each color should be enough to identify the color you're after. Small dabs of color can be added for tonal

Developing a practical order on the palette with respect to both materials and chromatic range is important.

Arranging Colors

Arranging colors on the palette is a highly personal choice depending on the chromatic range an artist selects and the pictorial procedure he or she plans to use. If use of colors on the palette is an important issue in other pictorial media, it is even more so in acrylics because of their quick drying time, which forces an artist to make optimal use of materials. Be careful not to put too much paint on the palette because if it dries there will be considerable waste. Arrange your colors in such a way as to give you logical and clean access to them; this can be done by range or tone.

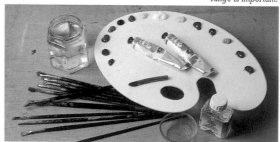

Detail of a palette in full chromatic search, with warm tones being developed on one side and cool tones on the other.

Even with an unconventional palette, colors should be used as needed.

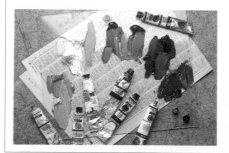

Skin Tones on the Palette
Acrylics on the Palette
Landscapes with Acrylics. Seascapes

35

Improvised Palettes

A resourceful painter does not necessarily need a traditional palette, any nonporous surface, such as Formica, plastic, or varnished wood will do. Even dishes, which are highly practical for working with liquid paints, make good palettes.

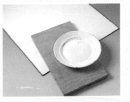

Different items that can be used as palettes.

Chromatic Approximations

To find a specific color on the palette, always begin with a base color that you can adjust for tone. Lighten or darken the base color depending on what you're looking for, but keep in mind that if you lighten a color with white it will become subdued and dull. The next color you add to your initial color will determine the chromatic nature of the mixture. Adding red to yellow will give you orange; blue will give you green.

nuances to either lighten or darken a tone. It is always better to add too little than too much of a color because, if you make a mistake and darken a color too much, you'll have to add more of the initial color, and in so doing risk making another error and wasting more paint.

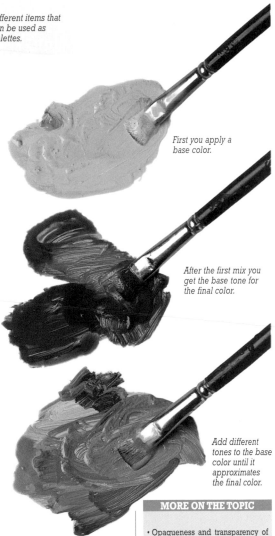

First you apply a base color.

After the first mix you get the base tone for the final color.

Fast Drying Time

Acrylic colors dry fast, meaning that colors on the palette can dry fast too. One way to prevent this from happening is to add a small amount of medium to the mixed colors using a moistened brush. Colors that have been mixed should always be used immediately because having been spread over the palette they will dry faster than globs of color.

Add different tones to the base color until it approximates the final color.

Use a damp sponge to clean the palette and prevent the colors from drying and becoming unusable for later mixes.

MORE ON THE TOPIC

- Opaqueness and transparency of the medium **p. 8**
- Making acrylic paint **p. 12**
- Palettes and mixing methods **p. 28**
- Mixing colors **p. 30**

LANDSCAPES WITH ACRYLICS. SEASCAPES

Acrylic painting adapts itself to all sorts of subjects and styles. Its great plasticity allows for the creation of all kinds of planes and textures, from glazes to impastos ranging from the deepest opacities to the most subtle transparencies. The landscape provides the artist with the opportunity to experiment with many chromatic and technical effects that would be impossible with other techniques.

The Sky and Its Texture

The initial glaze breaks up the whiteness of the paper and gives chromatic unity to the whole work; this base will prevent subsequent layers of paint from being absorbed. A grayish-blue tone is applied quickly with a palette knife. This tool allows the paint to be spread evenly and is also used to extend streaks of color in a marbled effect. Before the paint dries, several small dark blue and white dabs of paint can be applied that, when spread across the canvas with the palette knife, will fuse with the underneath layer of color and give texture to the entire sky.

Chromatic Approximation

After you select the subject of your landscape, sketch the main lines of your composition on the paper or canvas. It doesn't matter which medium you choose for your sketch because the opacity of the acrylic paint will cover all of the lines, regardless of how dark they are. The lines that shape the forms can be drawn with a thick brush and should establish the main areas without too much detail.

Landscapes provide great possibilities for acrylics.

Technique for applying stains to a freshly painted background.

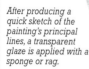

After producing a quick sketch of the painting's principal lines, a transparent glaze is applied with a sponge or rag.

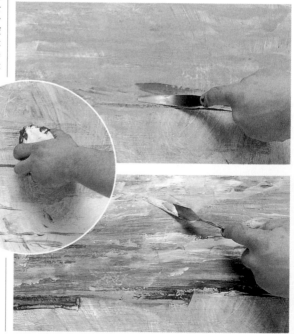

The stains dragged over the fresh background become tonal variations that give texture to the sky.

Acrylics on the Palette
Landscapes with Acrylics. Seascapes
Painting Skin Tones

37

The Sea as Contrasting Stains

Once the sky is dry, a piece of tape or folded cardboard is used to reserve the horizon. Then the entire middle area where the sea will be is stained with greens and blues, without concern about entering the area below because it will be painted last. Horizontal lines of white paint are applied as they were for the sky. The same palette knife is used to define with white smudges areas and masses that will be restated later with different tonal additions.

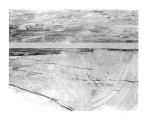

Tape is used to protect those areas that you don't want painted.

Drying Time and Superimposition of Layers

It is very important to observe and analyze the time it takes for acrylics to dry, as this is the only way to control the paint and its effects. If you intend to superimpose a layer of paint over another and cover it completely, the underneath layer must be totally dry, a process you can accelerate with the help of a hair dryer. You might be interested in maintaining a chromatic relationship between the two layers by mixing or dragging the underneath layer, but be careful to wait a reasonable amount of time if the paint is very watery; don't add the second coat immediately nor too thickly in order to not drag the underneath layer completely.

Varnishing the Painting

Color can diminish in tone if you haven't used enough medium or if the support is too absorbent. Sometimes tones and shades that are superimposed over other underlying colors become dull and fade into the background after drying. A layer of finishing varnish for acrylics can revitalize the colors of a painting, and, at the same time, keeps the paint from leaching back into the support.

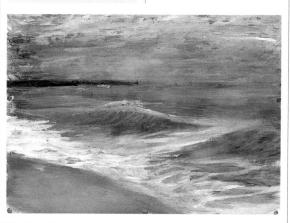

Blending of the white brushstrokes was done by diluting their edges with acrylic medium.

White mixed with ochre was applied over the shore area and directly over the color of the sea.

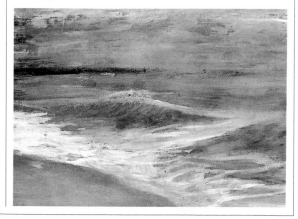

Glazes and Shadings

Acrylic paint dries quickly, which gives it a great advantage over other media. A well-finished landscape painting, in this case a seascape, is defined by the mood it conveys. When the landscape is completely dry, it is no longer possible to blend the underneath layers. The only way to lessen the impact of direct brushstrokes and achieve a certain tonal blending is to apply a glaze of opaque layers. This can be done by extending the limits of the freshly made brushstrokes with acrylic medium.

MORE ON THE TOPIC

- Acrylic landscapes **p. 56**
- Monochromatic landscapes **p. 70**
- Acrylic atmospheric effects **p. 94**

PAINTING SKIN TONES

Once you become familiar with the chromatic range of skin tones, you'll realize that no single color defines the color of skin, but rather that it depends on the brightness and kind of light focused on it. Therefore, the best way to master painting skin tones with acrylics is through practice, with each artist developing his or her own techniques according to the particular requirements of the painting.

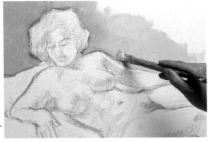

A well-structured sketch clearly separates the different planes of the figure and the background.

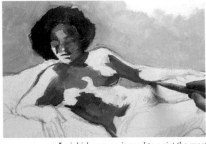

A pinkish-orange is used to paint the most luminous area of the entire figure.

Sketching the Figure

Sketching is the artist's most personal and indispensable form of expression. The principal shapes in the painting are suggested by the lines and shadings that outline the subject sketched, a crucial process in painting. Many artists, however, dispense with preliminary sketches or outlines and go straight to painting.

Acrylic paint can be applied like any other pictorial medium, but if you take full advantage of the medium's properties, you'll achieve increasingly better results.

Establishing Areas of Light

Unlike other pictorial media in which dark colors, particularly black, must be applied last, acrylics allow for overlays of color.

You can concentrate on working on individual areas, establishing from the outset the areas to be shaded.

There is no single color that determines the chromatic range of skin tones. When painting shaded areas, therefore, the darker tones are blended on the palette.

In this case, an ochre with sienna will be perfect to outline the darker areas, emphasizing the darkest shadows with burnt sienna.

Simultaneous contrasts heighten the intensity of the tones used.

Intermediate tones are painted as planes over already dry colors.

Shaded Tones and Simultaneous Contrasts

Once the principal areas of light have been established, you can develop intermediate tones and shadings for the darker colors. After the underlying layer of

Dark tones perfectly delineate the shadows.

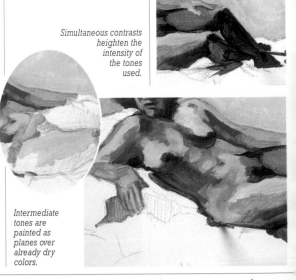

Landscapes with Acrylics. Seascapes
Painting Skin Tones
Principal Acrylic Techniques (I)

39

Practicing the Technique

The technique of painting skin tones in figures may seem quite difficult. It is an area that requires constant study and practice; however, technique is just a tool and as such should never enslave an artist. The value of a painting is not determined by the technique an artist uses but by what he or she expresses.

Skin Highlights

After having applied all of the intermediate tones, you will have a clear idea of the volume of the figure as defined by the flat colors. The darker tones bring out the areas of greatest luminosity on which light shines directly. These points or areas of light are painted in very clear tones, lightly retouching the smoothest areas of skin with white and adding pink tones to the hands and a more orange tone to the abdominal area.

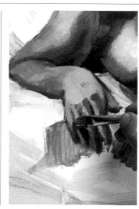

paint dries, you can apply an intermediate tone to soften the transition between the brightest tone and the shadow. Use an orange tone for the femur's frontal plane. A deeper orange color can be used to paint the upper part of the leg, while the calf area can be repainted with the dark earth color chosen at the beginning.

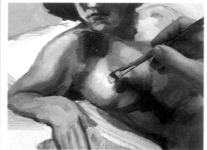

The hands and fingers are defined through bright pink planes that contrast with the shadows of the fingers.

MORE ON THE TOPIC

• Mixing colors **p. 30**
• Skin tones on the palette (color-ism) **p. 32**
• Acrylics on the palette **p. 34**

A pinkish, almost white, color is used to paint the brightest areas of the breast.

The entire abdominal area is painted by alternating different shades of pinkish and orange colors.

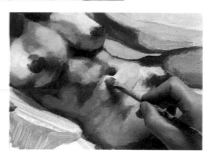

Masses have been constructed through planes; these can be smoothed out by using a transparent glaze.

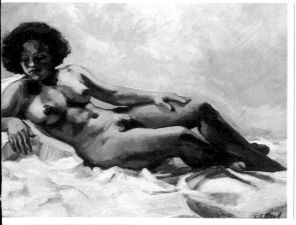

Glazing to Enhance Unity

When the entire body has been painted as planes, check to be sure that the darker planes penetrate the volume, while the brighter ones stand out from it. Even after achieving the desired chromatic range of skin tones, some colors might still appear to be out of harmony with the rest. To balance the effect of the color dissonance, you can apply a highly liquid glaze over the painting's entire surface after the underlying colors have dried.

TECHNIQUE AND PRACTICE

PRINCIPAL ACRYLIC TECHNIQUES (I)

Acrylic is perhaps the safest and most versatile painting technique. While for many artists the medium does not offer the subtle chromatic range that oils do, the issue becomes debatable when discussing acrylic works that even to the expert eye could be confused for oils. Acrylics afford an infinite number of technical possibilities that need not compete with other media; however, comparisons become inevitable when an acrylic reproduction surpasses the original.

Superimposed washes. The two-tone effect was achieved by applying a second layer over the first layer after it dried.

Superimposing Layers and Transparencies

The density of acrylic paint and its opaqueness can be easily altered, allowing an artist to produce an acrylic painting in a very short period of time as compared to the time it takes to complete an oil painting.

Acrylics can produce completely opaque or transparent layers of color, regardless of the paint's density. The painter can completely paint over an opaque layer with another color, after the initial layer dries. To these two layers can then be added other layers of color that have been diluted with acrylic medium.

Diluted wash. After wetting the entire surface, the paint was spread in directional sweeps, allowing the brush to absorb more paint in the brighter area.

Washes

Acrylics can produce subtle washes that can be carried out in two ways. One way is to moisten the surface of the support with a wet brush and add small amounts of acrylic paint to it before it dries. The paint will seep into the moist areas.

The other way is to prepare two containers with medium and a tiny amount of paint that is barely perceptible. Wetting the brush, you can produce controlled smudges on the dry support surface, overlaying different layers of color as soon as each layer dries.

The order in which layers are added is not important; completely opaque or transparent layers can be added by simply altering the density of the medium.

Texturing with Transparent Layers

Transparent layers can be used to create textures with acrylics. In fact, the medium lends itself easily to the texturing and modeling of forms using a brush. Depending on the pastiness of the medium, you can use repeated brushstroke patterns to enhance the painting's texture or create masses of various shapes.

This texture was created with lightly pigmented acrylic medium; the brush marks are due to the use of dense paint.

Monotypes

Monotyping is a highly rudimentary and primitive technique for creating stain impressions. In monotyping, a paper or other material is pressed on top of a paint smudge to produce unpredictable and amusing results. Before drying, the impression can be transferred to a paper or another painting support that may be white or colored. Monotyping allows the artist to create highly original textures and graphic designs that appear to be machine produced.

Monotypes tend to reproduce the forms over which they are pressed, but the effects are almost always unpredictable. Original stain.

Monotype pressed twice.

MORE ON THE TOPIC

- Opaqueness and transparency of the medium **p. 8**
- Making acrylic paint **p. 12**
- Thick paste (gel), varnishes, and additives **p. 16**
- Principal acrylic techniques (II) **p. 42**

Combining Techniques

When painting with acrylics, it isn't necessary to incorporate every technique the medium offers into your painting. However, it is important to at least be aware of the wide range of techniques available so that you may draw on them when necessary. Often, several techniques are present in a work without the observer being aware of it. This is a sign that the artist has made good use of resources and that these were for the good of the painting and not the other way around.

The first layer of black was covered with a transparent layer, with the contrast between the new and previous designs creating an atmospheric effect.

Alternating Planes in Space

Because acrylics allow superimposition of multiple layers, you can construct different spatial planes and create different moods by simply applying different layers of glaze over a surface.

If over a dark tone, black, for instance, you apply a transparent glaze of any color, the dark tone will become veiled and dull but still remain black. The contrast between the clear and the veiled tone produces a clear spatial difference between the two planes.

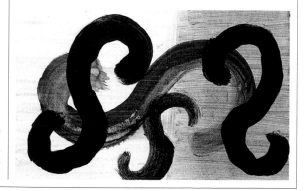

PRINCIPAL ACRYLIC TECHNIQUES (II)

The range of possibilities that can be achieved with acrylics ranks them at the top of pictorial processes. Acrylics can be prepared as liquid washes or thick impastos, and they dry almost immediately. Acrylics not only imitate the effects you can obtain with other techniques, they are also characterized by two of their own valuable attributes: quick drying and elasticity.

Blending converts one tone into another. Always add the new color by painting in from the edges of the original one.

Blending

Blending is the smooth transition of one color into another or into a tone of the same color.

Blending is the process whereby one color is smoothly converted into another. A specific color is applied to the support surface with a soft brush that is gently passed over the canvas toward the area where the blend will take place. When the edge of the original color is reached, part of the color or tone into which it must blend is added to the brush and with gentle passes is brought back to the area of the original color. This procedure is repeated until the two tones are fused.

Sgraffito

Partially dry acrylic can be worked in a number of ways. A commonly used technique is *sgraffito,* which consists of scratch-

Sgrafitto produced with the point of a brush.

ing a newly painted area with a pointed object. The sharper the point, the finer and more defined the line will be. On the other hand, if a rounded point such as the handle of a brush is used, the paint that accumulates on the sides of the impression will produce a feeling of volume.

Washes

Washes are among the most attractive effects that can be created with acrylics. The specific drying time of an acrylic depends on the absorbency of the support, the particular color, the medium used in the mix, and the temperature in the room.

In drying, the edges of an acrylic paint smudge dry first because the paint is quickly absorbed and evaporates; the center of a smudge dries last. You can take advantage of this gradual drying process by washing away and removing the paint that is still wet, preserving only the dry areas. The result is a very beautiful graphic.

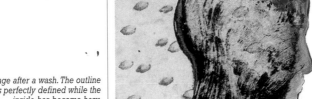

Image after a wash. The outline stays perfectly defined while the inside has become hazy.

Thick Transparencies

While virtually impossible to achieve with other pictorial media, thick glazes are easy to achieve with acrylics. A thick gel, with a little bit of paint or pigment added, is more than enough to produce a thick layer that will hold its texture after drying and that, depending on the load added to the gel, will be completely transparent or translucent.

Gel and highly diluted violet glaze on a white background.

| MORE ON THE TOPIC |

• Opaqueness and transparency of the medium **p. 8**
• Making acrylic paint **p. 12**
• Thick paste (gel), varnishes, and additives **p. 16**
• Principal acrylic techniques (I) **p. 40**

Experiment and Discover

The range of pictorial possibilities with acrylics is so vast that new techniques can be derived from ones you have already mastered. Thus, it is most interesting for the artist to experiment continuously with new plastic possibilities, including those that may seem ridiculous. Trial and error is the best road to success.

Dry Brush

A dry brush and very little paint will allow you to create rubbing effects with different superimposed layers of color or tone. This process must be done very quickly in order to prevent the paint from drying on the hair of the brush. It is advisable to use an old and worn hogshair brush so that you get drier rubbing effects.

Rubbing effect achieved with a little paint and an old, dry brush.

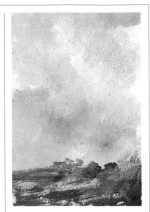

These two images show the effect of a wash on a wet background.

Glazing

Glazing, as its name suggests, consists of covering a color with a thin film, that is, giving to a surface that may already have several tones, colors, and shapes a certain tonal quality.

Glazing is done with an acrylic medium wash and any tone that has been added. The mixture is applied over a painted surface that is dry if you want to prevent changes in background layers, or over a wet surface if you want to fuse the layers. In the latter case, the glaze must be applied quickly if you want to avoid smudging the base color.

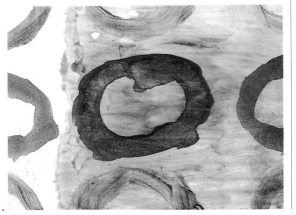

Thick glaze that makes the background figures on the support clearly visible.

PREPARING DIFFERENT SUPPORTS (I)

Acrylics can be applied to any porous support. Keep in mind, however, that while the medium is fully capable of adhering to the support, the medium's wetness can damage the support in ways that are similar to producing wrinkles in paper, twists in wood or cardboard, and loss of tension in canvas. To avoid these potential inconveniences, which are caused not by the medium itself but by the moisture in it, it is a good idea to mount the support on a stretcher that keeps the tension constant.

Materials Needed

Mounting paper on a stretcher, though not critical for acrylic painting, is recommended for certain techniques or when a light, portable support will be used, thus it becomes a matter of personal choice.

As each mounting method is done in a particular way with specific materials, it is important to have them ready before starting to mount the paper.

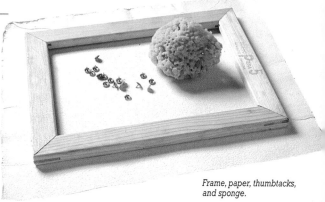

Frame, paper, thumbtacks, and sponge.

Choosing Your Materials

The results of a painting session depend largely on the materials you used to prepare your support. Paper and priming materials come in various qualities; buying a poor quality of either item can often be counterproductive. You should always use a heavyweight paper (90-pound paper at least). Industrial latex can be used as long as it is a quality brand.

Moistening the Paper

Mounting paper on a stretcher is most recommended when working on very large formats or with very wet paint.

Paper can be mounted using either glue or thumbtacks. Regardless of the method you choose, you'll need to wet the paper thoroughly in order to saturate it and dilate its pores; therefore, when you mount the paper later and fix its four sides to the stretcher, it will

contract as the water evaporates and remain as tight as a drum.

MORE ON THE TOPIC

- Thick paste (gel), varnishes, and additives **p. 16**
- Supports. canvas **p. 22**
- Priming for acrylic paint **p. 26**
- Principal acrylic techniques (II) **p. 42**

Paper that is completely moistened with a sponge.

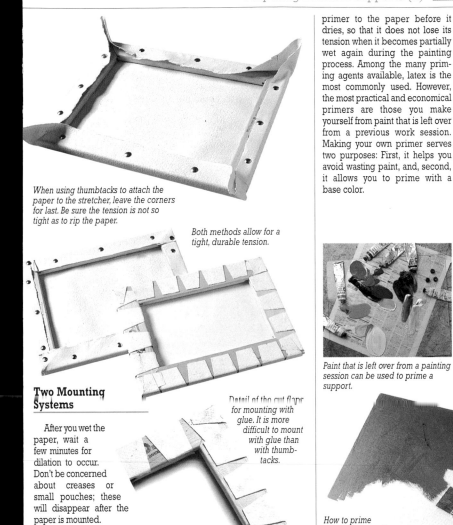

When using thumbtacks to attach the paper to the stretcher, leave the corners for last. Be sure the tension is not so tight as to rip the paper.

Both methods allow for a tight, durable tension.

Two Mounting Systems

After you wet the paper, wait a few minutes for dilation to occur. Don't be concerned about creases or small pouches; these will disappear after the paper is mounted.

The quickest way to fix the paper to the stretcher is to use thumbtacks: Place the stretcher face down on top of the paper, fold the paper back, and fasten its sides to the wood using the thumbtacks. The fastening should always be done symmetrically— first one side, then the opposite side. Leave the corners for last, folding them to one side and always making sure that the fold starts from the tip that sticks out.

Priming the Background

After the paper has been mounted on a stretcher, it is a good idea to apply an acrylic primer to the paper before it dries, so that it does not lose its tension when it becomes partially wet again during the painting process. Among the many priming agents available, latex is the most commonly used. However, the most practical and economical primers are those you make yourself from paint that is left over from a previous work session. Making your own primer serves two purposes: First, it helps you avoid wasting paint, and, second, it allows you to prime with a base color.

Detail of the cut flaps for mounting with glue. It is more difficult to mount with glue than with thumbtacks.

Paint that is left over from a painting session can be used to prime a support.

How to prime a paper mounted on a stretcher.

If you prime with latex, you can always add some color on the last pass.

TECHNIQUE AND PRACTICE

PREPARING DIFFERENT SUPPORTS (II)

While mounting paper on a stretcher is recommended for particular kinds of work, it is always recommended when using plywood and certain types of cardboard. Even though these materials make excellent painting supports, their surfaces can become damaged over time. A good stretcher that strengthens the support will help avoid this problem.

· ·

Gluing and Tacking the Support

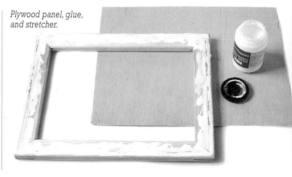

Plywood panel, glue, and stretcher.

If you look at the stretcher, you will see that one of its planes slants inward. The wood or cardboard will be mounted on the flat side of the stretcher so that the maximum possible contact between the surfaces of the two items can be achieved when binding them together. Apply a generous amount of glue to the flat side of the stretcher. Use a T square to check that the angles are right angles. Then turn the stretcher over and press it firmly onto the wood. Use a heavy object to apply a uniform pressure to the stretcher. After a while, nail the support to the stretcher, spacing the nails about 4 inches apart.

Even pressure should be applied for proper gluing.

Wood needs to be nailed down to remain securely attached to a stretcher.

Excess material should be carefully removed from the panel after it dries by running a cutter several times along its edges.

Adjusting the Support

When the glue is completely dry, turn the stretcher over and run a knife several times along its outer edge to remove excess support material. Begin by cutting gently, then use greater force on the last passes. The knife should not be very sharp in order to avoid nicking. When you've cut off all excess support material, sand the edges of the wood with sandpaper.

Cardboard can be easily cut with a cutter.

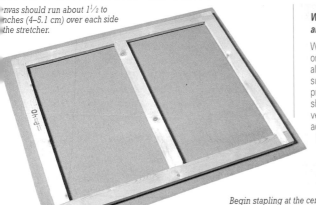

nvas should run about 1½ to
nches (4–5.1 cm) over each side
the stretcher.

What You Can and Should Do

When mounting any support on a stretcher, you should always prepare a primer if the support hasn't already been primed. Wood and cardboard should not be kept wet for very long; therefore, it is not advisable to dilute the priming medium with water.

Begin stapling at the center of each side of the stretcher.

Mounting Canvas

To mount canvas on a stretcher, you need a staple gun, pliers for pulling the canvas taut, nails and a hammer (optional), and, of course, the canvas and stretcher.

The canvas should be larger than the stretcher and run at least 1½ inches (4cm) over each side. Do not go over 2 inches, because that would make precise mounting difficult.

First, the stretcher is placed over the canvas, this time with its slanted side face down. Begin pulling the canvas, always from the middle of each side in alternate fashion (first one side, then its opposite side), adjusting the tension with pliers to neutralize the formation of pockets on the canvas surface. Tighten the canvas and staple it onto the stretcher, always working in the middle of each space left and leaving the corners for last. After the entire perimeter is stapled, fold the corners of the canvas over the edge of the stretcher and staple them, pulling the canvas tight and eliminating any remaining wrinkles.

Detail of the finished corners.

Nailing ensures an even tension.

MORE ON THE TOPIC

- Thick paste (gel), varnishes, and additives **p. 16**
- Supports. canvas **p. 22**
- Rigid supports and paper **p. 24**
- Priming for acrylic painting **p. 26**

AIRBRUSHING WITH ACRYLICS

Airbrushing is one of the most complex and, at the same time, spectacular graphic techniques in terms of the results that can be achieved. The importance of airbrushing in illustration art stems from its graphic potential to shoot small particles of paint onto a canvas by means of a continuous stream of pressurized air. The technique allows for numerous applications: tonal gradations, overlays of color, and transparencies, all of which can be carried out with such precision that the images created can closely resemble photographs.

The Tool and the Acrylic Medium

The airbrush is a tool that conducts pressurized air and regulates through a lever-controlled nozzle the mixture of paint and air it expels. The technique can be used to create a variety of blends and effects on any type of support.

Acrylic paints are an ideal medium for airbrushing, since they can be used in a highly liquid state without losing their plastic properties. While any quality acrylic paint diluted with a medium can be used, special compounds are commercially available for airbrushing.

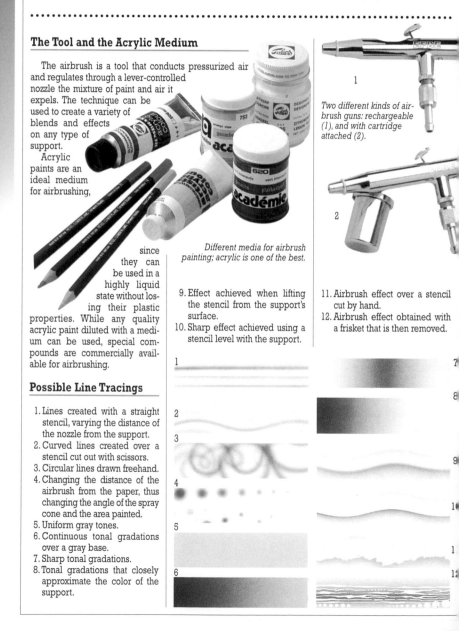

Two different kinds of airbrush guns: rechargeable (1), and with cartridge attached (2).

Different media for airbrush painting; acrylic is one of the best.

Possible Line Tracings

1. Lines created with a straight stencil, varying the distance of the nozzle from the support.
2. Curved lines created over a stencil cut out with scissors.
3. Circular lines drawn freehand.
4. Changing the distance of the airbrush from the paper, thus changing the angle of the spray cone and the area painted.
5. Uniform gray tones.
6. Continuous tonal gradations over a gray base.
7. Sharp tonal gradations.
8. Tonal gradations that closely approximate the color of the support.
9. Effect achieved when lifting the stencil from the support's surface.
10. Sharp effect achieved using a stencil level with the support.
11. Airbrush effect over a stencil cut by hand.
12. Airbrush effect obtained with a frisket that is then removed.

Masking Techniques

Masking consists of placing an object or a mask between the stream of paint and the support in order to leave some areas unpainted.

The mask can be made of paper, an adhesive that can be removed, or of liquid rubber that can be erased after it dries. You must always start with a very clear design that establishes the different areas to be colored, and mask those you don't want painted. Masks can be attached to the paper or be slightly lifted from it, depending on the particular paint effects you want to achieve.

Beyond Reality

Airbrushing allows an artist to create plastic effects that challenge, and, in many ways, surpass the effects achieved with photographs; therefore, the technique is being used by many well-known graphic artists in their commercial work.

Jumpei Ogawa. Sample of hyperrealism carried out with airbrushing techniques.

acrylic in areas where the background is a different color.

Tonal gradation effects vary according to distance between the airbrush and the support and the spraying time. Persistent spraying from a shorter distance will produce a solid, opaque tone, while a quick, light spraying will create a thin film of color, leaving the color underneath or the white support visible.

Persistent spraying close to the support produces opaque colors and more defined contours.

Use of a mask or stencil lifted off the support to paint a diffuse background. The main shape in the painting has been covered with a self-adhesive mask.

Shadows and Highlights

An advantage of airbrushing is that it will allow you to avoid using white paint and to create luminous areas using the tones of the paper or canvas themselves. However, if you wish, you can use a white

The final outlines are done with fresh stencils; pure white colors emerge when the frisket is removed.

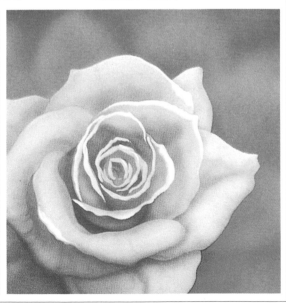

MORE ON THE TOPIC

- Principal acrylic techniques (I)
 p. 40
- Principal acrylic techniques (II)
 p. 42

TECHNIQUE AND PRACTICE

ACRYLIC PORTRAIT TECHNIQUE

A portrait is a portrait, no matter what technique is used, but obtaining positive results depends precisely on this question. Putting a technique to use should work to the advantage of the final product. Making use of the characteristics of each medium solves many formal difficulties, as well as habitual errors made by painters who are new to a specific technique. Many professional painters may have perfect technique when using oils or watercolors, and be wonderful masters in these areas, but their skill may be blocked if they are unaware of acrylic techniques or if they try to apply them like other painting media.

The artist has sought a pose that can be well structured, playing with the different changes of plane.

than any other medium to the development of modern paintings, since this field breaks with all the classical rules, both in developing the work and in its technical manipulation. The drying time required is minimal and the work can also be taken up again and again without changing the first layers of paint.

The Model and the Underdrawing

The acrylic medium allows for an infinite number of plastic possibilities, but it adapts itself better

The drawing provides structure rather than detail, giving particular importance to composition and proportions.

Establishing Areas of Color

In acrylic painting, layers of paint can be superimposed in a single session without removing the layers, and allowing, of course, for drying times. The different areas of color don't have to define

the shapes of each structure of the portrait model. It may be enough to create a simple chromatic approximation to be filled in later when defining each detail of the portrait.

Tonal Approximations

Shortly after the first colors are applied, they will be completely dry, and new colors can be applied to approximate the tones of the model. Acrylics allow us to use a transparent color to correct the base color, thus, if a transparent orange layer is applied over an ochre skin tone, the color is corrected in favor of the newly added tone without having to lay on another color from the palette.

The initial colors establish large masses, with the need to define their internal shapes.

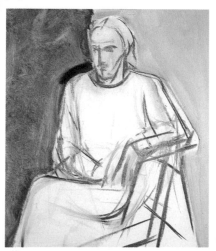

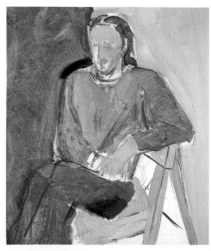

Airbrushing with Acrylics
Acrylic Portrait Technique
Mixed Techniques. Pastel and Acrylic

51

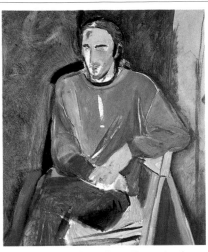

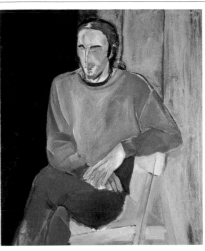

Colors adjust themselves to shapes. Nuances in volume are based on tonal variations of the base color.

The addition of new tones makes it possible to separate the planes formed by different features.

Adjusting Tones and Overlaying Color

On top of the colors already defined in the first layers, we can begin to correct the initial tone by superimposing new tones over the paint that is already dry. These changes in color are created by adjusting the tone on the palette, by adding white, red, or blue, depending on the light or the characteristic colors of the work being done.

Notice the solution given to the hands, where planes of shadow are differentiated with the use of dark colors.

The Figure and the Drawing

As the different areas take on shades of color, and the features of the portrait begin to be outlined in the painting, small dark and light planes establish differences of mass in the face. It is possible to include the profile drawing that defines lines such as the septum, or simultaneous contrasts can be established to effectively separate planes located at different levels, such as the face and the neck.

MORE ON THE TOPIC

- Skin tones on the palette (color-ism) **p. 32**
- Painting skin tones **p. 38**
- Principal acrylic techniques (1) **p. 40**
- Principal acrylic techniques (II) **p. 42**

Different levels of finishing have been used to establish the importance of each area in the painting.

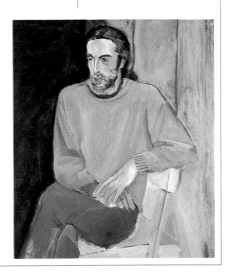

Avant-Garde Movements and the Academy

With the Impressionist avant-garde, a pictorial revolution arose in the nineteenth century with the support of new technical contributions such as photography. New perspectives and subjects were developed, as well as an understanding of shapes as masses of colors, an understanding that was far from the academic view that continued to propose the value of graded tones for modeling shapes.

MIXED TECHNIQUES.
PASTEL AND ACRYLIC

There are many artists who make use of different painting techniques in carrying out their works; however, it is not an easy task to find the point where the different techniques come together. There are media that are obviously compatible, such as tempera paints and acrylic media, since water is the suspension medium of their binding agents. Mixing with other media is apparently uncertain because the point of union is not clearly seen. Artists should not remain in suspense; they should do research and draw their own conclusions. Acrylics have a direct relationship with pastels even though this may not seem to be true.

Mixing on the Palette

Pastel colors use gum as the binding agent, giving consistency to the stick that sheds as it is rubbed across the paper and leaves pigment lightly stuck to the porous surface. If you touch pastels with your fingers, you can see that their stability is very low. But, if you mix pastels on the palette with acrylic medium or even with acrylic paint, you get an exceptional mix since the vivid color of the acrylic medium takes on the pastel tone of the dry medium but has the advantage of great stability when it dries.

Outlining the Shapes

Any painting technique requires using a more or less precise drawing depending on the finality of the piece. In a work where painting consists of the continuous development of shapes, the drawing will be constructive but without detail in the shapes. On the other hand, if the painting comprises a premeditated and detailed work, it is advisable to start with a very concise and studied drawing.

The outline has been drawn rapidly but gives perfect shape to the principal masses in the painting.

Where there is compatibility between acrylics and pastels, it is possible to conceive of a drawing that only structures the shapes, since as we noted when mixing on the palette, the tone of the pastel is absorbed by the moisture of the acrylic medium.

Notice the effect of using the same acrylic color with two different pastel tones. In the first we get a warm shade, in the second, a lead-gray tone.

Starting with Pastel

It is possible to start painting in pastel, bearing in mind that much of the areas that are painted at first will become the source of later direct mixing on the painting surface. Tracing with pastel sticks can be done straight or zigzag, making the quality of the tracing obvious. In areas where the planes of pastel are denser, later mixing with acrylic medium will in turn be pastier, and the color will be saturated with the base shade. Remember that pastel is pure pigment, chalk, and gum.

Acrylic Portrait Technique
Mixed Techniques. Pastel and Acrylic
Mixed Techniques. Oil on Acrylic

53

The initial tones will mark the chromatics of later mixtures with acrylic medium, which will drag part of the base color.

Flat Masses and Mixtures

There are two ways to begin painting on top of the initial application of pastel color. One way is by mixing directly over the pictorial support by dragging the paintbrush load against the pastel stroke until you notice that the cohesion between the two media is correct and no partial mixture remains. The other way is by mixing the color meticulously on the palette until the desired tone is obtained.

The first additions of acrylic over pastel should be blended in well so that contact between the acrylic and the pictorial support will be complete.

The addition of acrylic seals the support and the underlying pastel, adding new layers when the previous ones have dried, without altering the mix.

Alternating Techniques in Finishing

Both techniques are constantly involved in finishing, making use of the different resources that have been developed in this chapter. The clean stroke combines with gray tone staining and correcting, creating different planes and qualities, leaving some areas with a less deliberate finish in order to reinforce the different qualities of the painting.

Making Pastels at Home

Some of the best pastels are those made at home; it is easy to do, quick, and economical. You'll need a mortar, gum Arabic, precipitated chalk, pigments, and a mold-inhibiting preservative.

The first mix is the binder: 0.4 gallons (1.5L) of water, 1 ounce (30g) of powdered gum, and half a teaspoon of preservative. Allow to rest for eight hours.

White: Place 50 cc of chalk and 15 cc of binder in the mortar. Grind until you have a malleable mass. Shape the stick and allow it to dry.

Other colors: Mix the pigments with white chalk in different proportions to obtain tones.

| **MORE ON THE TOPIC** |

- Making acrylic paint **p. 12**
- Principal acrylic techniques (I) **p. 41**
- Principal acrylic techniques (II) **p. 42**

The different qualities of finish allow for highlighting through the contrasting of traced and stained areas.

MIXED TECHNIQUES.
OIL ON ACRYLIC

There is a constant tendency to compare the acrylic medium with oil, perhaps because of their similarity in terms of densities and the final results in finish; however, they are two completely different media. Acrylic is water soluble while oil is soluble only in oil or turpentine. A mixture of the two seems impossible, but, if one of the maxims in painting is observed (fat over thin), you can demonstrate that the acrylic medium allows for a quick start on the initial layers of a painting that can be finished in oils.

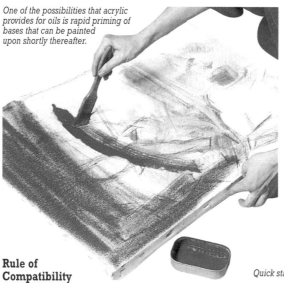

One of the possibilities that acrylic provides for oils is rapid priming of bases that can be painted upon shortly thereafter.

Quick Staining

The initial stains can be done in a general way, knowing that they will be changed later and that these initial steps in the painting serve only to place color that is consistent with the painting's structure.

Acrylic paints can even be used almost totally watered down without any consistency or density, in which case you have to paint on a flat painting without any tilt. When you begin to work with dense paints on a dry base, the painting can be placed vertically. In any case, many artists choose to work on a completely flat painting.

Rule of Compatibility

The acrylic medium can be painted over any non-oily surface. This is logical, since, when water is the vehicle for suspending the resin, mixing water with oil becomes impossible. However, the properties of the acrylic medium do not have to be rejected when painting in oils. On the contrary, if acrylic is used intelligently over the support, it is possible to use both media, combining the advantages of drying time and transparency provided by acrylics with the nuances and finish that oils can provide.

Manipulating acrylic paint when it is fresh makes it possible to open up blank and clear spaces that will be used later as the basis for painting with oils.

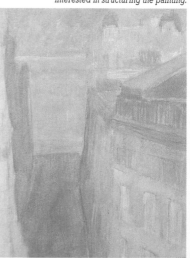

Quick staining omits detailed work; we are only interested in structuring the painting.

Mixed Techniques. Pastel and Acrylic
Mixed Techniques. Oil on Acrylic
Acrylic Landscapes

55

Some color details can be worked in acrylic.

The process of fusing two acrylic colors. The brushstroke is long and smooth, dragging part of the adjacent color.

Acrylic Evolution

Over the dried surface of the initial acrylic layers, you can begin to restate shapes, tones, and color, and you can even mix with the lower layers if they have not completely dried, achieving an interesting effect of solid and fused colors.

The development of the painting involves all kinds of acrylic work, including in some areas the fusion of tones or the incorporation of opposite colors that yield simultaneous contrasts.

The Principal Characteristics of Oils

One of the most important characteristics of oil paints is their pastiness and body. This quality makes it possible to work while maintaining an unchanged texture on the support, at the same time that tones and color fuse in soft gradations and tonal values. Oils can be used to paint almost any surface, provided it is well primed, making acrylic paint an ideal base for oils.

An acrylic staining of the entire painting is the basis for completing the painting in oils.

Creating Shapes and Masses

When you start with an acrylic base, you can begin to paint with oils shortly after applying the final brushstroke with acrylic. This is a great advantage since it has been possible to reduce to a single session a process that would have taken a considerable amount of time with oils. The additions made in oil make it possible to modify and finish the entire base of the painting with the quality that is characteristic of oils, making use of areas in the previous acrylic layers that may be of interest. Remember that oils are only soluble in turpentine oil and it is therefore not recommended that you use the same brushes that you used with the acrylic colors.

MORE ON THE TOPIC

• Making acrylic paint **p. 12**

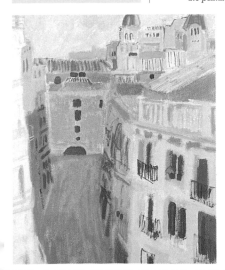

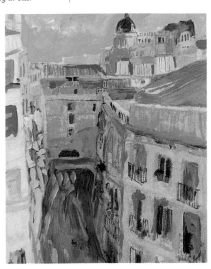

TECHNIQUE AND PRACTICE

ACRYLIC LANDSCAPES

The landscape is one of the subjects most frequently done by painters, both those who paint outside and those who prefer to work inside. The acrylic medium offers the landscape artist a large number of advantages that make this the most versatile of techniques, first because of the large number of technical possibilities—which alternate transparent, opaque, and superimposed surfaces—and secondly because of the immediate drying, which allows for numerous treatments during the short drying process: sgraffito, washes, or rubbings.

The principal clouds of the background have been applied over the blue sky, dragging some of the paint from the previous layer.

Depicting Clouds

For most landscape artists, the sky provides one of the greatest mysteries in terms of representing light on the landscape. Many artists consider the sky the center of interest in the landscape. Clouds act as reflectors of light and it is therefore very important to study then. Acrylics make it possible to work quickly, without forgetting the processes of fusion between the different tones of white, gray, and blue. The background of the sky is painted first with a few quick passes with blue. Before this dries completely, the cloudy area is applied with white, dragging part of the previous paint and placing the purest white on the areas with most light. Before this dries, the masses are joined with a fine brush.

Simultaneous Contrasts

Once the background of clouds has dried, tones are superimposed that fuse, based on circular and short brushstrokes in the upper areas. The addition of new tones means establishing new planes among the different contrasts, and it is possible to produce a landscape with great depth depending on the tonal perspective given to the cluster of clouds. This means that if the sky seems far away when tones are homogeneous, the sky will seem closer when the contrasts are more varied.

Over the white background, new layers of gray are painted with circular brushstrokes.

MORE ON THE TOPIC
• Landscapes with acrylics. sea-scapes **p. 36**
• Monochromatics landscapes **p. 70**
• Acrylic atmospheric effects **p. 94**

Alternating layers and tones allows for the in-depth treatment of clouds.

Over the sky blue background, small brushstrokes of white are applied as well as quick reddish passes from the bottom area.

When the background has dried, some orange shading can be applied to the bottom area. This will create a clear sky at dusk.

The Colors of the Sky

The sky never has the same color; it all depends on the light it receives at each moment. A completely clear sky will vary in color throughout the day.

Acrylic technique allows for a smooth transition between the tones of any color, as well as for applying added hues to alter the tone of the color once it has dried. Blue brushstrokes cover the surface of the painting. In areas with more light, small strokes of white are added, fusing them with the blue.

Brush Techniques

It is not enough to know how the acrylic medium behaves in terms of superimposition, transparency, or washes. None of this makes sense if you don't have firm control over the instrument that manipulates the medium—the paintbrush. Painters must experiment with new stroke techniques and with a variety of different brushes, developing their own techniques. Sometimes a very bad brush can be ideal for creating textured masses, something that would be practically impossible with a new, high-quality brush.

Effect of fusing the two moist tones.

Superimposing Planes

Acrylic technique makes possible a wide variety in the superimposition of planes, something that the landscape artist uses to achieve numerous effects.

The first stains establish the areas in a general way. These can be manipulated during the drying time. The entire background is painted first, such as, the posterior planes. On top of these, the composition of the first planes progresses, always in a general way and modifying the tone with nuances of color and different ways of treating the paint.

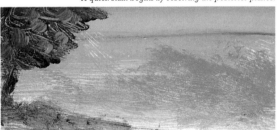

A quick stain begins by resolving the posterior planes.

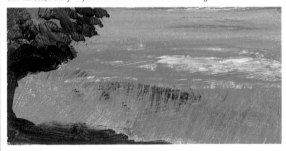

You can use a wet brush to manipulate the background plane, and an old, nearly dry brush to structure the texture of grass.

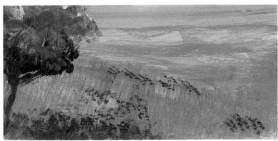

Landscape details can be worked over a completely dry background.

BRUSHWORK EFFECTS

Acrylic technique doesn't just consist of knowledge about the medium and the support. How it is applied is just as important as the medium itself because your technical knowledge of painting will not be worth much if you don't master the brush. Acrylic paint can be applied in different states of liquidity; its application will be equally variable depending on the condition of the paint and the support. The brush assumes a fundamental role in the technical treatment of paint, since it can leave a trail or be so subtle as to not leave any mark at all.

Strokes and Brushes

All artists use brushes adapted to their preferences without having to use a large number of brushes, since a single brush permits different uses, in terms of both stroke and load. One must select brushes with different degrees of hardness in order to develop different characteristics in brushing. Different types of hair allow for different strokes. If you're interested in working a large flat surface without—any hair marks—you should use a high-quality synthetic flat brush; a hogshair brush will leave its own trail.

Brushstrokes done with an absorbent brush over a wet background; washing and drying with a rag before again passing over the surface of the painting.

Different paintbrushes and palette knives for acrylic painting.

Effects on a Wet Background

When a layer of paint is applied over a primed background, drying is slower than when paint is applied over a dry background and allows for later manipulations of aspect, tone, or texture. Paint added over a wet surface has a clear tendency to expand, especially if it is in a totally liquid state. The brushstroke is used to divide and control the paint on the wet base. On the other hand, when the paint is still very wet, part of the paint can be removed with the aid of a dry brush with a good bundle of hair. Thanks to this wash over a wet surface, clear spaces can be opened up over the base of the support or textures with the width of the bundle of hairs on the brush.

Wet paint over a wet background.

Washing with a damp rag over a nearly dry background. The texture is achieved with an old pointed brush and very thick paint.

A worn brush over a wet background with a wavy movement.

Brushstrokes, Qualities, and Trails

The gesture, the pressure of the brush on the support, the width of the brush, the condition of the paint, and the support are the principal determinants of the brushstroke and its trail.

An old brush leaves an irregular trail. If we add a small amount of paint to this effect, the trail that will be left will be primarily graphic, and can be combined with the direction of the brushstroke to create a weave or texture. If the background is wet, the trail can be fused with it to expand the paint.

Nearly dry flat brush over a dry background.

Brushstrokes with Flat Brushes

The flat brush is one of the most frequently used brushes. Although it is much broader than most brushes, it allows for a wide variety of options both for staining and for producing graphics or textural effects. A nearly dry flat brush can create broad areas of texture. On the other hand, this same flat brush loaded with acrylic and worked flat makes it possible to outline in great detail over any wide area.

Versatility of Paintbrushes

With only a few brushes, it is possible to obtain most of the brushwork effects needed for acrylic painting. The same bundle of hairs allows for a wide variety of tracks along its path.

A twisting flat brush loaded with only a little paint over a nearly dry background.

Moistened flat brush over a nearly dry background creating a horizontal texture with fine, clear lines.

Using varied pressure to drag paint over the fresh background.

| MORE ON THE TOPIC |

- Acrylics on the palette **p. 34**
- Principal acrylic techniques (I) **p. 41**
- Principal acrylic techniques (II) **p. 42**

STILL LIFE

One of the subjects most frequently painted by the majority of artists is the still life. Painting objects in a picture is fun and allows us to experiment with less commitment of resources than when a live model is depicted. The still life requires great effort from painters in synthesizing the model in front of them, an issue that helps to develop an understanding of shapes as related to the volume of bodies within the space of the painting.

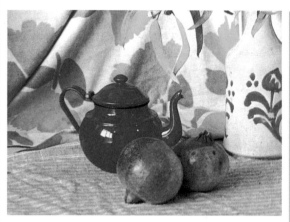

The model should be composed with balance since it will be the basic reference to be followed.

Each of the objects in the model occupies a place in the space of the painting, and although shadows and reflections are part of these objects, they should not be considered when doing the initial stains, in order to correctly indicate the shapes of the objects in the still life.

Adding Layers and Stains

Shortly after staining the painting, the acrylic paint will have dried completely and you will thus have an initial base of color to be adjusted with new tones. The acrylic base allows for the addition of later opaque and transparent layers. These can be modified very easily without altering the superimposed tone by blending it with colors that have already dried.

The Model and the Underdrawing

The shapes that are painted in the picture will undergo constant change while they are being developed. It is therefore more important to define the areas that will be occupied by each object rather than begin to provide details that will become useless when continuous layers of paint are superimposed. After observing the shapes of the model and the proportional relationships among the different objects, we begin the underdrawing with acrylic and a fine brush. The color used is not very important since it will serve only as a guide for the different areas of the painting.

Staining and Placement of Planes

The different planes are resolved based on the initial scheme, applying different layers of color in each of the selections separated by successive lines that mark the shapes of the still life.

In the first staining, the shapes should be left clear with general colors.

The base of color has completely dried. A correction can be added in the shaded areas without mixing.

Compose, Experiment, Find

A still life is one of the most interesting painting subjects since it allows the artist to delve into the study of shape, color, or any of the numerous values that can be found in painting.

Paul Cézanne (1839–1906) was one of the great students of painting through the synthesis of the planes of the model in the painting. His still lifes encompassed an elaborate study of reality reduced to simple geometric elements such as cubes, spheres, or cylinders.

Paul Cézanne (1839–1906), Still Life with Soup Tureen, oil on canvas. Musée d'Orsay, Paris.

The points of greatest light are resolved with direct smudges of white or pure color.

Defining Tones

The successive layers of color serve to provide nuance and definition for the tones. The brushstrokes can be opaque when they must cover an area to be corrected or transparent when varying a color or a shape on the basis of a glaze of any tone. A color can be changed with an acrylic transparency that affects only the tone, or it can be changed completely if the transparency is of a complementary color. For example, a blue can be varied in tone if the glaze is comprised of another blue, green, or white. In contrast, if the glaze is yellow, the result will be a greenish color, and if the glaze is red, the tone will change toward violet or purple.

Shading can be opaque or transparent. Opaque shading will cover the color, and transparent shading, as in this case, will modify the tone of the color.

Conclusion. Final Steps

The painting has been restated based on the adjustments with opaque paint and superimposed planes. The nuances with glazing have made it possible to create soft shadings and barely perceptible masses that nevertheless give the whole a pictorial interest.

The finishes of the painting alternate two pictorial languages, when you know how to make use of drying times. This means that before drying a shade of color can be applied over a transparent glaze. This highlights a specific shine, integrating the stain with its surroundings and blurring its shape over the glaze.

MORE ON THE TOPIC

• Color applied to composition **p. 86**

Successive layers of color have been altered when dry to give texture and when wet to blur them.

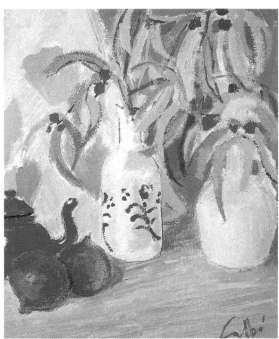

SYSTEMS OF COMPOSITION

The composition of a pictorial work is independent of the technique used to carry it out, since this is an issue that is common to all plastic representation. Once the various elements of the model are arranged in the painting, these can be shifted to achieve proper compositional balance. On the other hand, schemes of composition are very important in the visual rhythms of the lines of a painting.

Framing and Composition

Framing, as its name indicates, means situating the model within a specific stretcher, so as to have a reference both among the objects to be depicted and with respect to the limits of the stretcher that encloses them.

When an artist plans to do a painting, the first thing he or she does is decide upon the space in which to work; for instance, the artist becomes aware of the format of the pictorial support and compares it with an imaginary portion of reality.

The Search For Balance

Balance in art relates directly to balance as it is understood in physics.

Balance can be stable—when the object of the model stays in harmony with the space that surrounds it—without having to look for counterweights.

Balance will be unstable when it depends on different counterweights in the picture, and balance will be indifferent when it functions as the center of interest of the pictorial work viewed from any position.

A

B

C

A. Symmetrical composition, boring and monotonous.
B. Unbalanced composition.
C. Correct composition thanks to the slight displacement of weights of the model supported by the surroundings.

Internal Shapes in the Picture

A picture makes constant references to its own internal structure through the lines of composition and later the forms that the lines develop. To find balance in composition, a good method is to base the frame and the disposition of the different elements making up the picture on simple planes that internally construct not the object being depicted but rather a structure that maintains balance with respect to the surrounding frame. Later the picture will take shape.

Scheme of the internal structure in Derain's painting. It seems to be disorganized, but, as can be seen, the planes are counterbalanced as in a piece of construction.

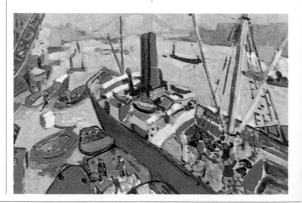

André Derain (1883–1954), The Harbor of London. Tate Gallery, London.

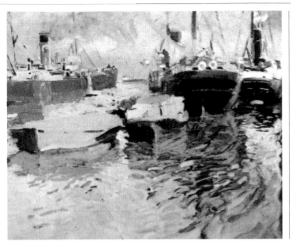

Geometric scheme of Sorolla's
painting, at left, formed by two
parallel flattened planes.

Joaquín Sorolla (1883–1923), Port of
Valencia. Museo Sorolla, Madrid.

Geometry and the Space of the Support

If the lines that structure the picture are important, the planes developed by these lines are equally important.

Composition is based on combining the internal structure of the picture with the planes displaced by such lines based on their projections. It is therefore possible to synthesize any shape in a simple geometric shape no matter how complex it is.

Interpretation and Composition

Composition is one of the painter's most creative tasks. In fact, great artists who painted by composing ended up composing without painting, developing abstract questions in search of form in composition.

In the area of figures, composition and interpretation of the model are intimately connected, since it is the job of the painter to develop a correct composition based on the synthesis of reality.

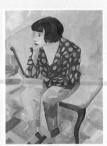

David Sanmiguel (1962), Aleydis
seated. Private collection, Barcelona.
An example of correct composition;
the figure that is slightly off center
remains perfectly balanced by the
masses of color developed
in the background.

Vincent van Gogh (1853–1890), Boats at Saintes-Maries.
Rijksmuseum van Gogh, Amsterdam.

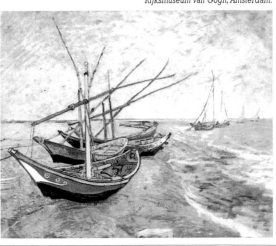

Scheme of van Gogh's painting
at right. Balance is achieved
by displacing the denser
planes to the left.

MORE ON THE TOPIC
• Color applied to composition
p. 86

ACRYLIC STAINING

Staining is the beginning of painting. In every painting technique or procedure there is a specific way to carry out staining. For example, oil techniques are slow-drying and allow staining to be done through a value system that fuses the added tones with those of the base color. Watercolors, because of their total transparency, require that the darkest tones be entirely definitive since lighter tones or colors cannot be added on top of them. Acrylic painting is quick-drying; its characteristics allow it to be painted transparently or opaquely; therefore, the staining of the painting takes on connotations quite unlike those of other painting media.

Warm, cool, and neutral ranges of color.

Keep Harmonies in Mind

Color harmonies mix within a specific range of colors, being chromatic possibilities that await a logical response in the selection of colors.

When staining a painting, it is advisable to be observant in the selection of the chromatics used, to be sparing in the range chosen, whether it is warm, cool, or neutral.

Development of Shape and Surroundings

One of the acrylic medium's great advantages over oils is precisely its accelerated drying time and its capacity and neutrality when bright colors are placed over dark or even black tones.

The Medium and Its Possibilities

Acrylic paint allows for a broad range of possibilities in its pictorial treatment, and therefore any possible type of staining can be contemplated, from completely liquid and transparent methods to the staining used with oil painting, which is dense and covers everything.

Since acrylic is so versatile, painters can adapt its possibilities to their own requirements, and since there is no one staining treatment, experimentation can lead the artist to carry out any approximation when starting to paint.

> **MORE ON THE TOPIC**
> • Brushes. types and characteristics **p. 18**
> • Mixing colors **p. 30**
> • Acrylics on the palette **p. 34**

Stains have been applied over a dark background, to define the shape of the masses.

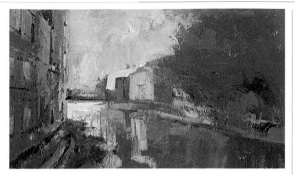

You can start to stain a primed surface almost immediately with a dark base. Drying time for this acrylic base can be shortened if a source of heat, even a hair dryer, is used. Over the dark tone of the support, stains of brighter color can be added that emphasize shapes by cutting away the painting's space.

Watery Staining

Just as a dense or opaque staining can be used, acrylic paint can be applied in an almost transparent way, as if it were watercolor. Tonal intensities can be increased with later additions of color that, naturally, can be opaque or transparent. If transparent additions are used, the tone underneath will be corrected as if applying a glaze treatment.

Superimposing Opaque Tones

Over an initial transparent, almost watered-down staining, a

Staining has defined the shapes of this urban landscape.

Over a scheme that has been sketched in, the painting has been stained with very watery, completely transparent acrylic.

new work process makes it possible to develop nuances that draw the stain toward developing the volume of certain fragments of the initial staining that will be used in later stages of the process.

The Staining Movement

All artists can develop their own language for staining on the support, and even more so when bearing in mind that the acrylic medium can be handled in different physical states. The artist's way of moving the brush represents the personal stamp that each artist gives to the brush-stroke. This can be more or

Each artist has a different style of movement, giving a personal touch to staining.

less expressive, giving rise to different styles in how the shapes of the model are understood. Staining will become freer and untrammeled as the artist acquires confidence and artistry.

Different superimposed layers are created by applying dense brushstrokes over the initial transparent staining.

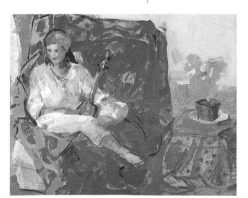

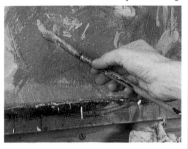

The initial staining allows the background to breathe through later layers of paint.

QUICK PAINTING TECHNIQUES

There's no better medium than acrylic paint for quick painting; its plastic and drying characteristics make it possible for the artist to use this procedure for any of his or her needs, with the certainty that regardless of the procedure used, the artist's work can range from watery tones like watercolors to thick daubs of color as can be done with oils, combining both techniques with freshness, speed, and perfect drying.

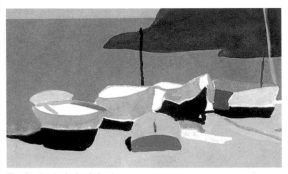

The drawing is the basis for the entire painting process. The acrylic medium makes it possible to lay down flat colors rapidly.

of finishing the development of colors by separate areas, one can continue painting with different shades that enrich the initial tones.

The first pass at painting is quick, but this later phase is even quicker, because there is a well-defined line to guide the brush and the new tone. Here it is more a matter of finding the nuances of shine or shadow than of redefining the shape with color.

Evolution of Shape

Another possibility for doing quick painting also starts with a flat, general staining; then, instead

One of the options for quick painting is to develop a completely flat work based on the previous base color.

Flat Staining

One of the characteristics of the application of acrylic medium is the ability to use a brushstroke that joins with other brushstrokes without any change in tone. This characteristic makes it possible to do a completely flat staining of the shapes, distinguishing between the colors from one area to the next and without doing any type of tonal value.

As explained earlier, the drawing is a fundamental issue because it helps us to understand each and every one of the planes as separate masses that are independent of each other.

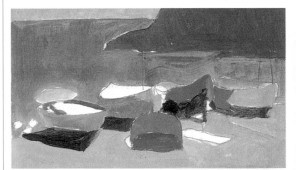

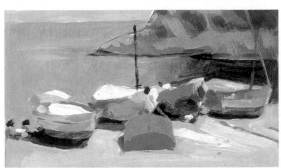

Starting with the initial staining, a work can be created by developing and superimposing tones to define shapes.

Intermediate Passes

The role of acrylics is essential to the quick painting technique since its quick drying calls for a finish without the risk of destroying the tone with unwanted fusion with tones or colors from earlier layers.

Over the developed or merely stained base, passes can be done with planes of color or graphics to accelerate the work's aspect. These intermediate passes can be corrected with opaque planes of color or, if the color was recently applied, can simply be removed with the help of a damp rag.

The Stamp of Movement

In quick painting, painters are greatly assisted by their own ability to resolve planes synthetically, without recourse to complications of form; thus, brush movement, sketching, and, above all, drawing ability are basic elements in these types of work.

All painters develop their own almost calligraphic language and, with time and experience, this language becomes more synthetic and explicit.

The movement of the brush helps to provide shape and direct the painting.

Details and graphics help to develop the different finishes of the painting.

There is no risk when applying new color over dry shapes.

The movement and tracing of the brushstroke over the general staining play a large role.

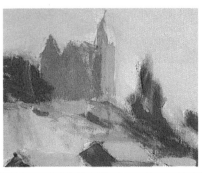

A detail of synthesis of shapes achieved with quick and direct smudges.

TECHNIQUE AND PRACTICE

HARMONIOUS DEVELOPMENT OF ACRYLICS

Harmony in painting and elements of composition are aesthetic subjects that follow some conventions of society and painting tradition. It is a logical human reaction to look for order in the pleasure provided by beauty, or to justify the absence of beauty on the basis of some theoretical reasoning. The search for painting harmonies develops a chromatic code language logically, associating colors with tones and the amount of light received, regardless of the style being developed.

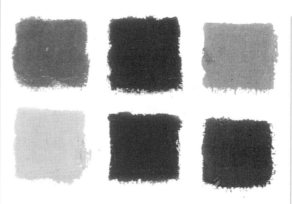

Samples of the warm range.

the support, or mixed using superimposed transparencies.

The warm tones seek maximum luminosity in yellow, bearing in mind that when mixed with white they become opaque and dense.

Cool Range

Blues, greens, and yellows are the colors included in the cool range, but several other tones and colors derived from the use of warm colors make it possible to develop a complete harmonious range. When cool colors are corrected with small nuances of warm shades, they take on a new chromatic value. For example, a blue to which red has been added becomes violet, which, although clearly a cool color, has a warm

Harmonies in Color

The color of different objects in a model is due to the light they receive. This means that there is a certain chromatic coherence between all the elements of a given model. It can be said that light bathes the objects in a painting, giving them a tonal veil that is not like some other lighting.

When painters decide on the palette to be used, they may do so independently of the colors in the model. This means that artists will interpret the real colors on the basis of personal taste. But when the colors to be used must correspond with reality, a concordant relationship is formed among the colors that is like that of the colors in the model.

Warm Range

The warm range includes the red, earthy, and yellow tones. Based on these tones, an infinite number of warm harmonies can be created. The acrylic medium allows the superimposition of different tones, permitting opaque and transparent colors. With this technical characteristic, the different colors in the warm range can be mixed before painting on

MORE ON THE TOPIC
- Landscapes with acrylics. seascapes **p. 36**
- Monochromatics landscapes **p. 70**
- Acrylic atmospheric effects **p. 94**

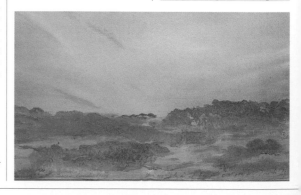

This landscape was produced with the warm range although the use of greens has not been rejected.

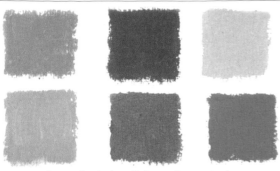

A range of cool colors with the use of warm colors in the two patches in the center.

Only cool shades have been used for the sky in this landscape but earthy red, and ochre tones have been used in the blends for the lower section.

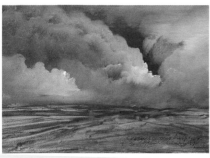

tendency. In the same way, the tone of greens can be changed within their own cool range when yellow is added to them.

Neutral Range

The neutral range is the most ambiguous of the three chromatic ranges. The colors in this harmony are all compounds; in other words, there is no pure color. Each color is obtained on the basis of the uneven mixture of two complementary colors and white, for example, three part carmine, one part green, and one part white.

These colors allow for great freedom in painting since any addition from any of the ranges is taken up by a chromatic group that has white as its unifying link.

Figure done with neutral colors. This range has room for all the chromatic hues united by white.

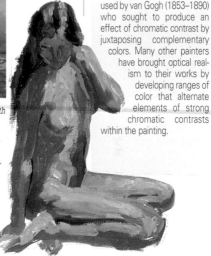

Raoul Dufy (1877–1953), Deauville. Kunstmuseum, Basle.

Chromatic Dissonance

There is not always a reason for using a harmonious range. In fact many great works are characterized precisely by the opposite, by the use of optical realism, a painting system used by van Gogh (1853–1890) who sought to produce an effect of chromatic contrast by juxtaposing complementary colors. Many other painters have brought optical realism to their works by developing ranges of color that alternate elements of strong chromatic contrasts within the painting.

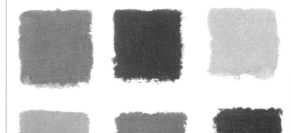

Range of neutral colors.

TECHNIQUE AND PRACTICE

MONOCHROMATIC LANDSCAPES

Often a painter works almost completely without a specific range of color or, if using it, can choose to limit chromatic variety to heighten drama or smudging. The monochromatic effect is often more harmonious than any other richer color option. Of course, developing a work based on a single color is not an easy task, but it is simpler than using all the colors on the palette. This is an important issue for many new painters because contact with the painting medium becomes less complicated.

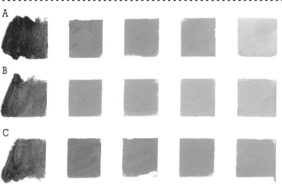

The Monochromatic Range. Grading of Shades

Monochromatics means developing a pictorial work with the tones of a single color, although it can be shaded with another color within the same harmonic range. By itself, the use of monochromatic painting is like drawing in terms of its development in grades of shading rather than in colors—but a painting is still a painting.

The different grades of shading with acrylic can be obtained in various ways: by progressively increasing the original color with another color from the same color scale, by reducing the color with white, or by developing a work on the basis of washes.

The acrylic medium makes it possible to alternate dense areas such as clouds with other transparent areas, such as the landscape below, in order to obtain an atmospheric effect.

Three different ways to understand monochromatics with acrylic colors of the same green color. A. Green graded with titanium yellow. B. Green graded with titanium white. C. Green graded by washing.

A variety of cool tones.

Monochromatics in Cool Tones

A monochromatic work can be developed with any color, and this color can be worked in any of the ways shown earlier or by using the three gradation systems. If you know the options provided by the acrylic medium, each option can be used for different treatments.

The cool tones are the green and blue colors. They will be brighter when they are mixed with brighter tones or treated like washes. These tones are ideal for painting initial planes and for great luminosity. On the other hand, they become opaque when they incorporate white.

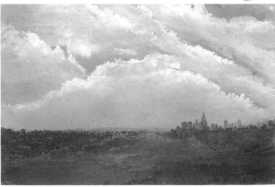

MORE ON THE TOPIC
- Harmonious development of acrylic **p. 68**
- Acrylic atmospheric effects **p. 94**

A complete range of acrylic red including an English earthy red.

The pinkish tones have been obtained by mixing with white, orange tones by mixing with yellows, and darker tones by mixing with burnt shadow.

Gray Ranges

Gray is understood to mean the scale of tones that goes from black to white, excluding these two colors themselves. In this way, it is possible to apply a gradation to different colors, particularly to the cool ranges. Broad gradations of gray can be obtained based on one color by reducing the intensity of the color on the basis of white and no other color.

The Use of Red

The tonal gradation of mono-chromatics done in red can be enriched with the addition of an earth tone. The different reddish shades can vary and be enriched when depicting the different planes in terms of their proximity to the viewer, leaving purer tones for the planes that are closer.

Just as the color white in the cool range produces a cloudy effect of distance, when it is used with red tones it converts them to pinkish tones. Therefore, if you want to produce a red gradation, it is always more effective in terms of shades to work with brighter shades of red or with washes of the same color.

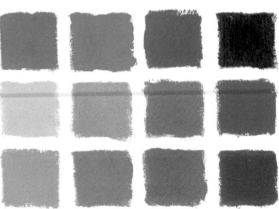

Different cool tones grayed with white.

The use of grays can add a lot through the synthesis of color in shading gradations.

Study of Light

One of the best ways to study light on different objects is by depicting them monochro-matically. The acrylic medium facilitates this task since its gradation is done as if it were watercolor or with brighter tones from the same range.

TECHNIQUE AND PRACTICE

ACRYLIC WASHES

It is possible that acrylic technique is broader than any other painting procedure. Its great plasticity and ambivalence allows the artist to experiment with constant variations on technical effects, thus increasing the variety of personal touches. The acrylic medium develops in a watery vehicle. This characteristic allows the painter to regulate drying while manipulating the paint, creating an infinite number of plastic possibilities. Washes should always be done with the support lying flat.

Graphic Effects

Graphic effects are entirely controllable when allowance is made for the drying time of the acrylic paint on the support. This is not difficult to do but it must be remembered that a graphic will be created on the basis of the same drawing that was done with the brush and that, to obtain an effect of continuity, the stain must be uninterrupted. A good exercise is to draw wavy forms with a brush; if the paint is not very liquid and a flat, hard hogshair brush is used, the trail left by the brushstroke will become part of the graphic. On the other hand, if the brush is soft and the paint is watery, there will be no trail left.

The white area has a small amount of paint. In contrast, in the dark area the line has produced a smudge loaded with paint that has not been allowed to dry.

Glazing with a Wash

Washing with acrylic medium is not only used to create graphic effects; it can also be used to create various types of glazes and hazy gradations. On top of the

Washing by grading. This has been blended after wetting the underneath area with clean water.

The graphic has been done with a continuous brushstroke. Before the surface dries it is washed, leaving only those areas of paint that are driest.

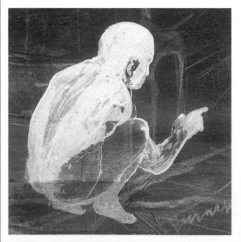

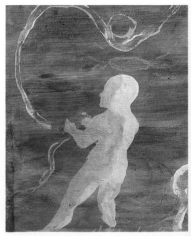

In this image, we note the ochre tone achieved with a transparent glaze.

support, you can glaze and shade over an area that has already dried; therefore, if an object is painted over a colored or white surface, its edges can be shaded into what was already painted by wetting the area beforehand.

Effect of white scumbling over a dry blue background, using a brush with soft hairs.

Effect of scumbling with a hard, flat hogshair brush to obtain the effect of rain.

The background of this image has been done by absorbing paint with a clean, damp brush.

Controlled Scumbling

Scumbling is a technique common to all painting procedures. It consists of scrubbing an almost dry brush over the painting, leaving marks from the hairs in the brush. The use of scumbling in acrylic painting is varied; it can even function as a wash, altering the painting level underneath.

Absorption by Areas

Absorption consists of removing an amount of paint from a specific area; this can be done with a brush or sponge. After painting a selected area, the brush is washed. The wet brush or a sponge is then used to moisten the area you want to clean. Several passes with the brush or sponge will remove the excess color.

Personal Development

Painting techniques and methods should never be the final purpose of a painting; they should be used as tools and adapted to each painter's own personal work.

Ramón de Jesús (1965), The Monster's Friends (1996), acrylic on paper. Private collection, Madrid. Washes, scumbling, and masking have been adopted as part of the painter's customary technique.

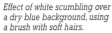

MORE ON THE TOPIC

- Principal acrylic techniques (I) **p. 40**
- Acrylic atmospheric effects **p. 94**

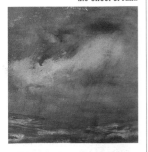

TECHNIQUE AND PRACTICE

FLAT PAINTING

Until the appearance of acrylic painting, painting in flat colors was limited almost entirely to posters. When the acrylic medium broke into the world of art, techniques such as those used in Pop Art grew, not only vindicating technical reproduction but also elevating posters, comic strips, and daily objects to the level of a work of art, as Marcel Duchamp had done in 1913. This time, however, in the 1960s, the rebirth was in the hands of Warhol or Lichtenstein, moving away from Dadaist philosophy.

The different colors are handled area by area; now the brown color of the hair has been painted in.

The Importance of the Drawing

One of the principal foundations for all artistic representation is the drawing; without this tool, it would be impossible to carry out any project.

The painting to be developed consists of completely flat colors without any type of valuation. The different areas of the drawing must be perfectly delineated with closed lines.

Closed Structures

A color and a tone correspond to each of the areas drawn. As these are perfectly delineated, there will be no difficulty in developing each of them as a separate plane. While the order of the areas painted is not particularly important, it is important to leave the smallest details for the end.

The different areas of contrast have been drawn with a clean and clear line, tracing the image over a transfer paper.

Color by Areas

Each of the areas drawn has a different color that cleanly cuts off the adjoining color. Therefore, the last area painted must be very precise and applied very cleanly over the completely dry layer of the adjacent color so as not to blend tones.

When you are painting a general area that includes details with some precision, the color can cover the area completely, provided you are working with transparent tones and the color will not cover over the drawing that you use as a guide at all times.

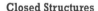

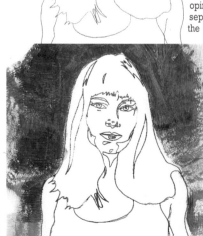

The background color is painted first; there is no need to be very neat.

The transparent color allows us to see the lines of the drawing.

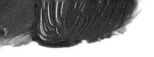

Progression of Tones

On top of the color already painted in, you can make as many changes as necessary to clean or correct a tone. If one of the colors you have painted has to be brightened or shaded, you only have to wait until it dries before adding the new shade. This new shade can be transparent or opaque, brighter or darker. Depending on the type of work you're doing, you'll want some contrast between the different tones. To achieve this, you will obviously have to change some of the masses of color that have been applied on the painting.

Adjusting Color

As the contrast between the tones is adjusted, the shapes of the masses of color cut each other off, defining more sharply the borders between them.

When the final color of each area has been completely determined, adjustments are made in the small details. Shaded areas are created with dark tones, and brighter areas with brighter colors or even white. Finally, when the painting is completely done, the entire drawing can be outlined again.

There was hardly any contrast between the background and the hair, so the green color was replaced with a brighter color. The color of the face was corrected in the same way.

After the final tones are applied, contrasts in the details are established.

Poster Art Tradition

Poster art has traditionally used painting methods that show the ability to do a flat painting, without tonal alterations on a surface that dries rapidly and, if possible, matte. For a long time, tempera was the appropriate medium, but the acrylic medium has come to replace it because it allows for better overlaying of planes without dulling the planes underneath, and because it is completely resistant to moisture.

Corrections have always been made to entire areas of color. Finally, the entire shape of the lines has been redrawn.

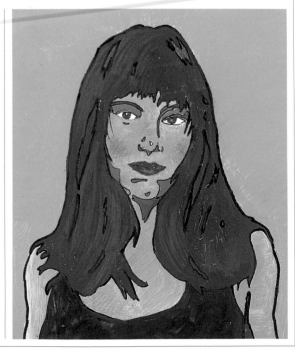

MORE ON THE TOPIC

• Skin tones on the palette (colorism) **p. 32**

ACRYLIC AND COLLAGE

Collage comes from a handicraft hobby developed in France during the nineteenth century. It consists of pasting different cardboard, paper, or fabric objects on a support. The art has developed by adopting handicraft techniques to the point that collage is today as important as painting. In many cases, the combination of acrylic painting and collage results in works of indisputable pictorial and plastic quality.

Papers painted with acrylic. Drying is rapid and serves as a priming.

Different Materials and the Acrylic Medium

The materials used in collage can be cardboard, fabric, or paper from the most varied sources: magazines, posters, photos, packaging, and so on. The objective is to use the composition and texture of these materials on a painting support and to integrate the different shapes within the chosen composition. The process of integrating shapes in the work is based on the association of forms and colors, assimilating chromatics or texture within a common plastic language.

The support and glue or latex, indispensable for making a collage.

Different paper cutouts.

Priming of Supports

Any support can be suitable for making a collage, but because all types of materials will be pasted to it, it is advisable to use a rigid support that can in turn be mounted on a stretcher.

When you're going to use a rigid support such as cardboard or plywood, it is always better to prime the support with gesso or simply with acrylic medium. In this way, the support will not absorb too much moisture and will keep its shape without creases. You don't need to apply a lot of priming but it should be homogeneous and uniform.

The Color Ranges

The various acrylic colors are completely compatible with any type of paper; it is possible to prepare painted papers as well as direct cutouts of "raw" paper from magazines or simply colored sheets of paper. Some papers can provide interesting effects in the collage, such as colored onionskin or lacquered paper, since their own color dissolves when it comes into contact with the moisture of the acrylic medium.

The tones that can be used in the collage can be like those on a palette of paint with the advantage that the color will be prepared beforehand.

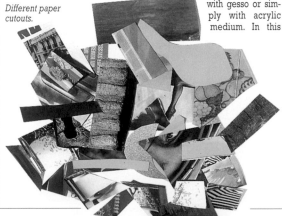

The color range can be chosen before beginning the process of cutting out shapes, as shown here where images with warm tones have been chosen.

Magazines and Photographs

The best material for making collages can be found in magazines since they provide a wide variety of images, but you can also make your own material from photographs or even photocopies of photographs.

Testing on the Support and Finishing

Based on the final sketch, tests are done as needed before starting to paste on the shapes, as some of the colors may need to be changed. In this case, all you have to do is take the cutout and repaint it or make another cutout from a different piece of paper.

Cutting Out Shapes

The composition of a collage is similar to composition in painting, except that you already have the shapes and masses of color before you start. When you've decided on the model to be depicted, start to select shapes, colors, and textures. Based on the shapes cut out, you can do a schematic drawing of the collage project. You can then study the composition in a more objective and graphic way.

The adhesive used can be any acrylic component.

A preliminary sketch can help you lay out the composition.

The shape to be cut out is based on the space it will occupy on the support.

Paper sheets of any color can be used in collage but this is always more expensive than painting them by hand.

Final result of the previous sketch. Touch-ups with paint have been added over the collage to unify shapes.

MORE ON THE TOPIC
- Supports. canvas **p. 22**
- Rigid supports and paper **p. 24**
- Abstraction in a painting **p. 92**

TECHNIQUE AND PRACTICE

LIGHT AND SHADOW

In almost all figurative painting methods, there are basically two ways to understand the model: First we have the classical view, developed by most artists until the emergence on the artistic horizon of the Impressionist group at the end of the nineteenth century. This view interprets the model based on valuation, that is, lights and shadows are done through tonal gradation of colors, thus modeling the motif in the painting. The other view, contributed by the Impressionist painters, is colorism, which, as opposed to valuation, produces colors based on the mixture of lights and shadows on the retina of the viewer.

Chiaroscuro and the Tonal Range

The areas of light in a body depend on the focus that illuminates it; thus, we can understand shadow as a progressive variation on illumination ending in its absence.

Bodies have volume, and the light that reaches them is what reveals the texture and the planes making up the bodies. In other words, a lighted area will progressively darken as it ceases to receive direct light.

Light falls on the point closest to the focal point; shadow covers the rest of the shape.

Gradation brings tonal scale to the volume of the shape, following the plane of the shape.

Using the tonal range helps in treating the valuation. The most luminous color is done using the base color with white and tones are added until reaching the pure tone. Then colors are added to darken the tone until nearly reaching black.

Underdrawing for a Valuation Work

A valuation work requires a concise drawing where we can see volumes perfectly through line. Therefore, the structure of the model must always be done on the basis of a completely volumetric grid in which the study of each of the different planes is facilitated without abrupt cuts. The acrylic medium allows for soft work through gradations while the paint is fresh, and can be blended and fused with other tones.

MORE ON THE TOPIC
- Harmonious development of acrylic **p. 68**
- Color applied to composition **p. 86**

In this drawing, you can see that the different volumes follow rounded shapes. This makes it easier to apply lights and shadows.

Copying the Masters

The best way to understand the play of light is by copying the great masters, who copied their predecessors. Courbet (1819–1877), the father of realism, knew the work of Caravaggio (1571–1610) and Rembrandt (1606–1669). He learned from them the technique of chiaroscuro, developing his own masterful painting technique through copying and personal study.

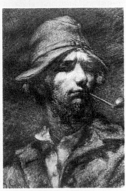

Gustave Courbet (1819–1877),
Self-Portrait with Pipe,
charcoal on paper.
Wadsworth Atheneum, Hatford.

Shades in Gradation

After you establish the different areas of valuation through the transition between brights and darks, with the acrylic paint in a semiliquid state and reducing the thickness of the color with medium, begin to unite the different chromatic areas, obtaining soft tonal gradations in the volumes. When the painting has dried, you can apply denser, dry brushstrokes to shade the different tones and heighten contrasts in the modeling, incorporating on the palette the colors that indicate the location of shadow as compared to light.

Rapid Interpretation of Modeling

Modeling means interpreting the figure based on its tonal gradations, the artist should know how to differentiate among the light areas of the model. To achieve this, nothing is better than continuous exercises designed to interpret the play of lights and shadows. You should first locate the areas of shadow in the model, using tones from the color scale

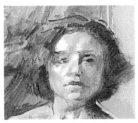

The two areas are joined with intermediate tones.

that you are going to handle. Then locate the planes of light, striving to make very clear what space is being occupied by each of the different areas. Finally, join both areas, using intermediate tones.

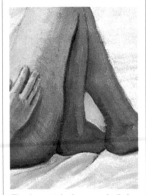

The deepest shadows are shaded with greens and blues.

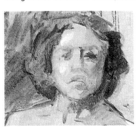

The shadowed area has been presented with a warm violet.

The shadows in the face are reddish.

The lighted areas are stained with orangy flesh tones.

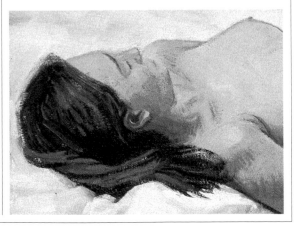

COLORISM IN ACRYLIC PAINTING

As opposed to valuative interpretation, colorism does not try to model volumes on the basis of chiaroscuro, but rather understands colors as areas of light in different objects. Therefore, shadows are not interpreted as gradations of a tone in the object being depicted, but rather as colors of their own, independent of the lighted area. Complementary colors play an important role in colorism since the different planes of the painting are defined through simultaneous contrasts.

Optical effect between contrasts of complementary colors. These colors become brighter when they are in contact with each other.

Smudge and Brushstroke

Acrylic colorism allows for painting of flat and uniform smudges that dry quickly. This characteristic facilitates rapid staining and a great ability to overlay different layers of color. These layers, whether transparent or opaque, can be placed on top

The first layer of color is very watery; a more opaque and brighter yellow smudge is added on top.

The different added planes contrast with each other, overlaying each other in a nearly pure state with hardly any tonal changes.

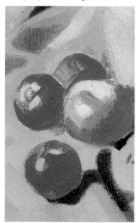

Play of Contrasts

Contrast in all its meanings is the primary characteristic of colorist painting. The acrylic medium makes it possible to handle pure, lively colors, and working with acrylic colors, provides a great advantage because you can be sure that their brightness will not be dulled by drying.

Planes in colorism are handled, not through the process of valuation or tonal gradation, but, rather, each plane is given a local color that is not necessarily tonal with respect to adjoining colors.

Simultaneous contrast is also achieved through the juxtaposition of two tones; a dark color always makes its neighbor seem brighter and vice versa.

81

Light and Shadow
Colorism in Acrylic Painting
Domestic Painting. Interior Scenes

of each other without dirtying the added color with unnecessary blends. Since the paint can dry in a matter of minutes, the smudge from the brush can be broad or small; it will dry in the same amount of time. This is done with a flat brush when you want to cover a large area or with a rounded brush when doing details or specific points.

Flat Colors

Flat color is one of the technical foundations of colorist painting. Valuation is not needed since the different planes are created on the basis of the contrast created between the different colors or between the simultaneous tonal contrast. The application of color is done within each area, bearing in mind that each of the added

The process of colorist staining. The flat colors find their counterpoint in their complements but both colors are in turn permeated with the neighboring tone.

colors will have a chromatic effect on neighboring colors and tones, depending on the light that reaches each plane and the chromatic purity of the new color.

Explaining Shapes

Through the juxtaposition of different planes expressed through color, the different shapes of the model are created. Contrasts bring out the various treatment of light on different surfaces, depending on their placement with respect to the focal point.

The Great Colorist

Vincent van Gogh (1853–1890) was one of the artists who best developed all facets of colorism, although obviously his work was done in oils. Pure colors seek their complements and simultaneous contrasts are constant throughout his work. If acrylic paints had existed in van Gogh's time, he surely would have used them in most of his paintings, accelerating the pace of a creation that was already very rapid but also very studied.

Vincent van Gogh (1853–1890), Vase with Flowers. oil on canvas. Rijksmuseum, Amsterdam.

| MORE ON THE TOPIC |

- Mixing colors **p. 30**
- Acrylics on the palette **p. 34**
- Color applied to composition **p. 86**

TECHNIQUE AND PRACTICE

DOMESTIC PAINTING. INTERIOR SCENES

Acrylic painting is an excellent medium for developing all sorts of subjects. Often, avid painters are not able to go outside to paint in the open air, they don't have models, or they're getting bored with still lifes. In these cases, they can find it interesting paint in their own studio or a corner of the, house. This type of exercise can develop the entire acrylic medium technique; it is also one of the most enjoyable subjects, and can give rise to multiple interpretations.

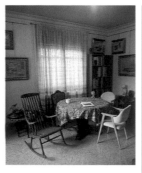

Underdrawing and Interpretation of the Model

Acrylic paint can be handled transparently or opaquely; therefore, the underdrawing of the motif on the painting may be completely defined when transparencies are to be done. Or there may be a general under-

The underdrawing has been concise, specifying each of the different planes and objects.

When you look at the model, you can see that the flattened under-drawing provides greater width.

drawing encompassing only the principal masses when dense and opaque painting is to be done, and the shapes will be reformed again and again.

Selecting the Chromatic Range

The general staining of the interior scene to be painted should point to a specific chromatic range in order to create a unique atmosphere. To do this, tests are done on the palette until the most interesting range is found. Colors should be selected before you begin to paint, since once the painting is started, the entire chromatic range will revolve around the colors used at the beginning.

Developing Different Planes and Notes

Starting with the general staining that approximates the shape to the color, the areas that have remained blank are defined as new planes when shaded with tones that give them volume, contrasting with the large masses of color already painted. The acrylic paint used dries quickly, even more quickly if used over a background that is already dry. The type of brushstroke also influences the paint's drying time; if the brushstroke is thick, it will take longer than if the brushstroke is soft and quick. This is why the first layers of color are lightly applied. The new planes of color are handled as rapid and clean notes.

MORE ON THE TOPIC

• Harmonious development of acrylic p. 68

The acrylic used is quite transparent; the painted details should increase its opaqueness.

Colorism in Acrylic Painting
Domestic Painting. Interior Scenes
Subtle Nuances on Flat Colors

83

This first level has been resolved very quickly, painting the radiator with a few, precise brushstrokes.

Atmosphere in Interior Settings

One of the most interesting methods for achieving atmosphere in an interior scene is to be almost monochromatic when painting most of the color range, using one color and its possible shades. When you have to use others, have them saturated with the general tone of the range used.

Redrawing with Paint

The shapes that have been concisely diagrammed from the outset take shape with the paint itself, which details the areas of contrast that make it possible to distinguish each of the planes of the elements in the painting. It is enough to change the tone of a color to distinguish one plane within another, redrawing the plane with paint since it is the shape of the chromatic mass that will distinguish the painted elements from the background of the painting.

The cat in the scene has a color similar to that of the background; it will be necessary to vary its tone so that its shape stands out against the rug.

Notice how the shapes have been redrawn by creating a soft contrast between them.

Detail Based on Contrast

Details don't have to be very concise; they can be barely insinuated, but there are many ways to insinuate a detail or a shape in a painting. One way is to paint the shape just as it is. Another more interesting and more subtle way is to have the form become apparent by contrast with its nearest plane, hardly having to paint it at all.

Details have only been suggested by contrast with adjoining planes.

TECHNIQUE AND PRACTICE

SUBTLE NUANCES ON FLAT COLORS

Flat color is understood as color that lacks tonal variation and presents no modeling of any type. On the other hand, a painting done with flat colors does not have to lack nuances. In fact, acrylic painting makes this possibility very easy, since mixing on the palette as well as on the painting allows for the development of a large range of tones. A simple, linear subject leads the painter to develop the ability to synthesize shapes and to practice on subtle chromatic changes in the painting.

Priming the painting base with a broken gray.

Starting with the initial drawing, black acrylic is used to paint what will be the base of the painting.

oped in the painting. For example, a grayish tone would be appropriate in most situations.

Establishing the Pictorial Base

To develop a luminous color on a painting, it is always best to start with a pictorial support with a tone that is darker than the color to be developed. The purpose is to heighten the simultaneous contrasts in the process of chromatic elaboration.

The white support can be primed with any other color. This color may be pure but it is best to look for a neutral tone that does not affect the colors to be devel-

Detailing the Shape of the Painting

In a work with flat tints, the different shapes should be perfectly delineated, so that the planes in the painting can be resolved cleanly without linear ambiguities that can lead to errors.

A good exercise is to do rapid drawings in a sketchbook, with a central figure that stands out with very clear strokes and continuous lines. This approach will help you to determine the shape.

Applying the Initial Colors

When you develop a work with a limited range of colors, it is very important to take care to find these colors on the palette, mixing as necessary until obtaining the initial tones that will serve as the basis for developing the entire painting. The two main colors are painted over the delineated

The colors applied respect the lines, thanks to the brush used, a number 14 flat synthetic hair brush.

The Color Registers

The variety of tones and shades that can be obtained from a single color with only a few changes in the thickness of application or in the possible addition of other tones provides great potential in the tonal register. Acrylic colors are highly susceptible to any change in blending, even with colors from their own range.

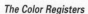

Ramón de Jesús (1965), The Will-o'-the-Wisps, *acrylic on paper 20 x 14 inches (50 x 35 cm.) Private collection. Madrid. This painting has been done in red, black, and white.*

Domestic Painting. Interior Scenes
Subtle Nuances on Flat Colors
Color Applied to Composition

85

Since the paint is completely flat, the development of the painting is very rapid.

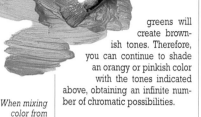

When mixing color from different shades, you can use all the colors without breaking with the color you want to modify.

greens will create brownish tones. Therefore, you can continue to shade an orangy or pinkish color with the tones indicated above, obtaining an infinite number of chromatic possibilities.

The Progression of Flat Colors

Over a fresh acrylic base, colors blend with each other easily. For this reason, you don't have to allow the base color to dry on a painting when you want to achieve a subtle gradation of tones. The shade obtained on the palette can be applied on the painting using a brush with soft hair, blending with the background.

shapes, with one color used for the background and the other for the skin tones in the figure. The yellow color of the background is pure, while the uniform tone of the face has been obtained by mixing red, white, and a little bit of yellow ochre. These initial tones should be applied with a flat brush that outlines well.

On the still fresh base, reds have been added on the forehead and cheeks, blues under the eyes, and white to lighten the tones of the forehead.

Color and Shade

Developing different shades within a single monochromatic range is done by progressively adding different tones of color from the same range or complementary colors, so that the amount of color added never manages to completely eliminate the color being shaded.

It is possible to add an infinite number of shades over any color without having to break with the color. For example, a red can be shaded with a touch of yellow without becoming orange; pinkish tones are obtained with small amounts of white; the addition of blue can result in violet tones;

MORE ON THE TOPIC
• Flat painting **p. 74**

The areas of the painting to be used for the clothing have been left for last because they are not particularly complicated.

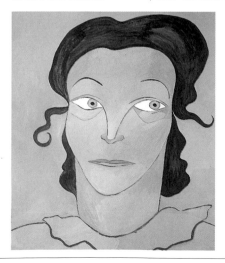

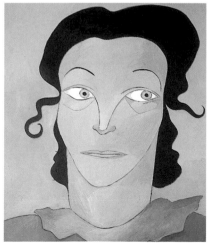

COLOR APPLIED TO COMPOSITION

The study of composition is one of the most important elements in a painting, since it balances the underdrawing and the different structures within it. Along with the study of composition, it is necessary that balance include the issue of color, since color has visual weight and requires good distribution in the painting, a system of color relationships that alternate contrasts, distance planes, and overlays. The acrylic medium is useful for any treatment of color and texture, so that the study of color becomes one more tool of composition.

A rigorously studied drawing has been established, seeking proportion among the different elements in the scene as well as with respect to the frame selected.

Structure and Study

It is not an easy task to understand the space in a painting. What's most important for good composition is to structure the shapes of the principal elements, thus establishing what the different location planes will be. A good underdrawing presupposes an understanding of its different proportions and measurements, and if you know that a completely opaque acrylic will be used, you can do a drawing that observes the different comparative heights among the proportions of the elements in the painting.

The dark smudge causes imbalance in the frame.

Chromatic Start

When the different shapes in the painting precisely occupy their respective spaces in terms of the underdrawing, we can say that the aspect of composition has been started, because we now have to determine the possible chromatic combinations that will give some areas greater weight than others, thus balancing masses with the weights of the colors that shape them.

The bright colors contrast with the principal shapes, seeking balance between shape and color.

The first applications of color are very watery.

The weight of the dark tone is offset by increasing the mass of the bright color.

Tonal Distribution

The initial layers of acrylic color can be very watery, first, because they only have to serve as an approximation of color, and second, because an excessive amount of texture in the initial layers could hinder the later development of the painting. The first tones should be distributed rapidly, seeking to adapt color to shape and trying from the outset to find contrasts that separate the different planes in the work.

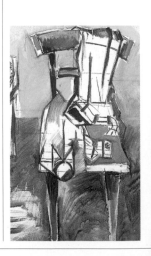

MORE ON THE TOPIC

- Mixing colors **p. 30**
- Acrylics on the palette **p. 34**
- Abstraction in a painting **p. 92**

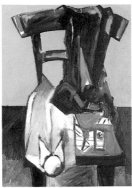

The brushstrokes applied after the colored underdrawing will be denser and more definitive, blending the color on the palette as well as fusing tones on the canvas.

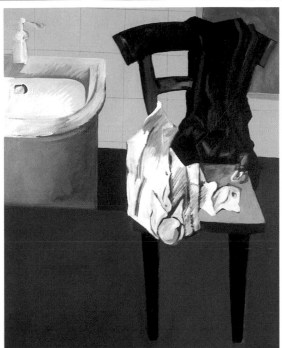

Adjustment of the colors has been completed, bearing in mind that each of the planes in the painting contrasts with neighboring planes. Contrast has been the principal tool in the search for chromatic balance in this painting.

Balance of Contrast in Planes

Contrasts of luminosity and brightness function in a painting the way squares on a chessboard do. Each shape is understood because it has alongside it a shape that defines it.

The different planes in a painting are defined and treated on the basis of color. In areas where a dark tone turns out to be too imperceptible or makes for unwanted confusion between two planes of color, it will be enough to work with either of the two conflicting planes of color and add some light or tonal shade that makes the shape obvious.

Notice how the simultaneous contrast of the two tones works. A grayed and whitish orange, placed next to a powerful red, results in great visual power.

Definition and Contrast

Color should be tested on the palette, comparing the mix with the tone on the fabric and trying to achieve tones that are not weakened (remember that a color is not weak in itself, but is affected by the tones and colors that surround it). Therefore, a grayish color can be located within a context of pure and brilliant colors. Both will form a contrast and gain in chromatic intensity.

A Constant Rule

Balance between color and composition has been one of the constants throughout the history of painting. One of the most controversial and complex painters of the Baroque movement was El Greco, however, his work is rhythmical and makes great compositional sense, always supported by the use of tonal and simultaneous contrast between colors.

Domenikos Theotokopoulos, El Greco (1541–1614), The Virgin Appears to Saint Martina and Saint Inés. *The composition follows an ovoid scheme, and; the colors help us to understand the rhythm.*

APPLYING MATERIALS USING MASKS

The ability of acrylic paint to allow for all types of loads gives this medium a breadth of unequaled plastic possibilities. The resin of the acrylic medium when it dries is condensed and hardens, forming a resistant, elastic, and homogeneous whole that can trap any added object within it. Masking consists of covering over a part that you don't want to paint, making it possible to use any type of material within the reserved space.

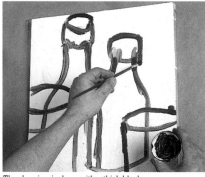

The drawing is done with a thick black acrylic and a brush that leaves a thick trail.

How to apply the masking tape over the completely dry drawing.

An Obvious Drawing

The mask makes it possible to concentrate amounts of paint within a marked area so as to not stain adjacent areas and allow the paint to dry in a controlled manner. In this case, we want to create a work with material loads of acrylic, sands, and marble dust. To do this, we will need to start with a perfectly studied drawing, done directly with acrylic and paintbrush. The level of error in the sketch is not particularly important since the main part of the drawing will be determined by the mask made on it.

The Mask over the Line

When the paint has dried (black dries very quickly), the entire drawing is covered with the help of masking tape, in such a way that the tape is always within the line because it will be used as a mask when adding new layers of color. How the tape is placed is important since the tape always determines the shape that will be left by the newly added color. Although it is made of paper, the tape has some elasticity and can be molded to the curves or stretched to form a slightly finer line.

General Staining

The first layer of color will be used as the base for later applications of acrylic and materials. This layer is applied with a wide flat brush so as to cover the entire surface of the painting. The entire mask can be covered, but whenever it will continue to be used as part of the drawing, it is better to leave a small part unpainted to indicate where it was located.

Over the taped area left unpainted, an entire uniform layer of thick paint is applied.

MORE ON THE TOPIC

• Making acrylic paint **p. 12**
• Thick paste (gel), varnishes, and additives **p. 16**
• Masks for flat tints **p. 90**
• Abstraction in a painting **p. 92**

The Risk of Using Loads in a Painting

The different loads of materials leave impressions in the acrylic with interesting plastic effects, but the painter runs the risk of stagnating with facile technique. This should not happen. A technique, such as using different loads, must be used intelligently for a painting to have more than a superficial value.

The thickness of the first layer of paint can be used as a base for later applications of materials.

Areas of Material

The layers of paint should always be allowed to dry before new masks are applied. Drying can be accelerated with the help of a hair dryer, without bringing it too close to the paint, since excess heat can destroy the paint. Once the dryness of the pictorial base has been tested, the areas that will contain the loads of material are masked. This time the masking tape is applied with its full width, as only the inside areas are of interest.

Applying new masks to add loads of material.

How to apply the previously thickened and loaded paint.

Masks are used until the end as long as you want to keep areas untouched.

Completing the Painting

When the painting with its load of materials has dried completely, the mask can be removed to test the condition of the area left unpainted, but the painting is not yet finished. The first masks made should still be used to apply colors by areas without affecting colors in the adjoining shapes.

When the masks are no longer needed, they can be removed carefully, without tugging. Then the painting can be re-touched in the masked areas, or tones can be blended in sections where the paint is still wet.

Once the mask is removed, new effects can be created like this white glaze.

MASKS FOR FLAT TINTS

Acrylic color can be applied in such a way that there is no tonal variation within the painting surface. This ability, along with the medium's rapid drying, allows us to use frisket film that perfectly seals very specific areas so that the result is neat and precise. When we remove the film, the planes remain clearly delineated, another possibility to be developed.

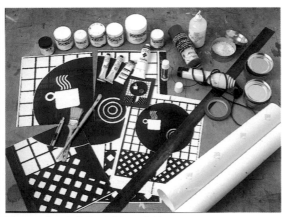

These are the principal materials needed for creating a work with masks.

Basic Materials

Great precision is needed to work using masks with completely flat tints. The acrylic medium permits this type of work, but some special materials are needed. In some cases, they must be purchased at stores that sell technical drawing materials.

The basic materials are: frisket film (a self-sticking transparent film mounted on a white protective sheet) a ruler (aluminum if possible so that it can't be cut with a knife) an expansion cutter, masking tape, adhesive spray, glue in stick form, a dryer to accelerate drying time, acrylic medium, acrylic colors, paintbrushes, and pictorial supports (wood if possible).

Masking Technique

Masking entails covering areas that should not be painted. The frisket film is used for this. Since the proposed work is completely geometrical, a preliminary sketch has been made and enlarged with a photocopier to the size that is planned for the painting.

The enlarged sketch will be glued over the frisket film, since each of the shapes will have to be cut to be used as a mask. The photocopy is glued after being sprayed on the back with spray adhesive. This should be done on cardboard or paper so as not to stain anything with glue. You don't need to use much but to ensure adhesion, it is advisable to spray the usable part of the frisket film too.

Order of Overlay

The order in which the different layers are overlaid is very important because you have to paint the areas that take up a larger surface first,

The enlarged photocopy must be pasted over the mask.

After cutting out the central pieces and removing the largest piece, the entire unmasked area is painted; later, the outer mask is removed.

The Condition of the Painting

Another Type of Mask

Masks can be made with many materials. Insulation tape and masking tape will allow you to make perfect curves. Ordinary adhesive tape and sealing tape are useful for making masks with straight edges. Masks can be made in numerous shapes with paper, cardboard, and plastics.

Depending on the finish to be given to the painting, the paint may be more or less liquid. When you want to paint a completely flat surface without any type of texture caused by the brushstroke, particularly on large surfaces, the paint should be milky. Drying will remove any mark left by the brush. On the other hand, if you want to leave marks or brushstrokes, the paint should be thick and compact. In this case, the film should be removed before it is completely dry so as not to drag the entire painted area.

Once everything that has been painted is dry, a new mask is made with adhesive tape to paint the areas with blue and yellow.

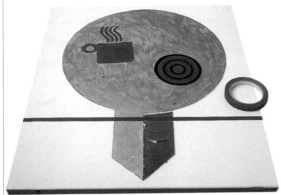

To paint concentric circles, everything is first painted in red. Once dry, the entire circle is again masked, and the rings that should be painted black are cut and removed. Black paint is then applied and the mask is removed.

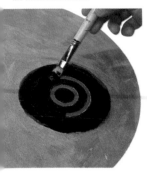

Over the blue and yellow surfaces, masks are made with adhesive tape to paint the linear elements with thick paint.

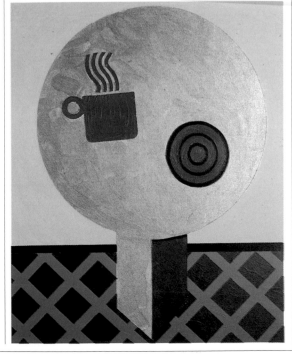

leaving room for small details that have to be laid over them. This noticeably reduces the chances of making a mistake, since it will always be easier to touch up a smaller area than a wide surface for which the color is no longer on the palette, unless a pure color has been used.

MORE ON THE TOPIC

• Flat painting **p. 74**
• Abstraction in a painting **p. 92**

TECHNIQUE AND PRACTICE

ABSTRACTION IN A PAINTING

Abstracting the concept of a painting is perhaps one of the most complicated aspects of art. When dealing with abstraction within the language of an artist, much more is required than a representation that is far from reality or from the formal and classical aspects of painting. Terms such as *difficulty* or *merit* are irrelevant, since abstract painting assumes an intellectual attitude when it is done consciously. The acrylic medium is one of the most suitable for abstract production, both because of its plastic potential and because of the painter's ability to reflect on a process that is as rapid as it is intense.

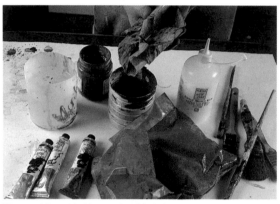

The materials used in this type of work include acrylics developed and made by the artist.

Composition

Composition is often the only reference in abstraction, since when working with pure abstraction there are usually no references other than the different variations of the planes of color or shapes on the painting.

Acrylic paint allows for a rapid, if not immediate, working process,

The initial layer of paint is applied with the hands.

so that the painter can avoid doing a prior drawing on the canvas and devote himself or herself to moving the different shapes and colors over the work.

General Staining

Staining of the piece is started after painting the entire surface with a flat color. Some artists use wide brushes, while others use flat brushes, but the best way to

spread the paint is by hand, without being afraid of getting dirty. Remember that acrylic is removed very well with water while it is wet. Afterwards, it can easily be removed from your hands with soap and hot water. Washing is important because some pigments, such as cadmium, are toxic and can be absorbed through the skin.

Dragging and Changes

Over the layer just applied, you can do all kinds of manipulations, for example, you can paint a specific shape and dry it lightly with a hair dryer. Since the two lower layers have not dried completely, you can pass a damp sponge over the new shape and everything that has not dried completely will be dragged, creating a broken textural effect.

A shape is added over the previous layer, which is still fresh. If a dryer is used, some areas will dry; others can be dragged with the help of a damp sponge.

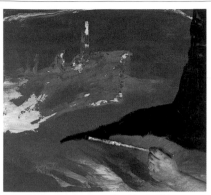

When a shape is painted over the side, depth is established with respect to the background.

The last application is moistened with a sprayer, eliminating part of it through a washing effect.

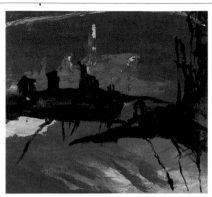

A new shape is added over the earlier base, which is completely dry, without any risk of blending the colors.

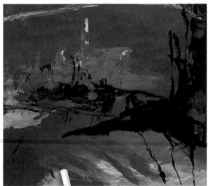

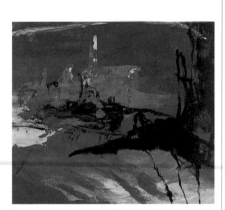

Finishing the Work

The new black shapes are laid in over the completely dry background. This time, the idea of planes of location is presented and balance of composition is sought among the different shapes. The first shape puts great weight toward the right. This is done with a fine brush, so that careful profiles can be drawn. To offset this weight, a second black shape is painted toward the center of the painting, but the composition thus obtained is too heavy, even though the shapes are interesting. To take presence away from the new shape, a spray of water is applied; the wetter areas of the acrylic are washed and part of the lower layer is left uncovered.

Participating in Painting

Many times, particularly for the new painter, painting can become a rein on creativity, since the goals we set for ourselves are too rigid. Painters should try to become part of their works, allowing themselves to be carried away by them and taking advantage of chance, errors, and successes as learning tools for later works.

MORE ON THE TOPIC

• Principal acrylic techniques (I) **p. 40**
• Principal acrylic techniques (II) **p. 42**
• Flat painting **p. 74**

In this work, all types of things have been painted, but the result is a completely integrated set of shapes with a certain harmony of composition.

Enjoying Painting

Painting must be enjoyable for the artist; it does not have to become a form of torture nor should you set up unattainable goals. Artists should know or study their own capabilities. Abstract painting is more complicated than figure painting, but it is much more enjoyable when the painter is truly free. In addition, the painter can study without formal criticism when doing abstract paintings.

ACRYLIC ATMOSPHERIC EFFECTS

The worst reason for rejecting something new is ignorance. Because of ignorance, many painters are reluctant to accept the acrylic medium, asserting that it is only useful for painting in flat colors. Nothing could be further from the truth. The ability to create great atmospheric spaces with acrylic is one of this medium's best qualities, and it can compete in brilliance and density with the most developed oils.

Over a fresh blue background, work has been done with white alone.

Over a background similar to the one above, dark blues, reddish tones, and whites have been blended.

Atmosphere and Blending Ability

The atmospheric effect influences all the elements in a painting, precisely because of the density and coloration of the atmospheric layer. The distance between the different planes increases atmospheric density, placing between the model and the viewer an air density that progressively eliminates the brightness of colors.

Acrylic paint makes it possible to interpret these tonal changes with its ability to blend with fresh paint on the painting, adding notes of color that progressively shade a specific area until achieving the desired point of light or density.

| MORE ON THE TOPIC |
| • Landscapes with acrylics. seascapes **p.36** |
| • Acrylic landscapes **p. 56** |
| • Harmonious development of acrylic **p. 68** |

Participation of Tones in the Painting

All the colors on the palette contribute to creating atmospheric effects in a painting, keeping in mind, however, that the luminosity of the sky affects all the different planes and elements in a painting. The colors that appear in the sky can be the same colors used to model the landscape. If we want to obtain a cloudless atmosphere, we can increase certain tones as the depth of the landscape is created. If we want to depict a dense or misty atmosphere, we can use tones that fuse with the sky.

Points of Light and

Two different tones are equally present throughout the painting.

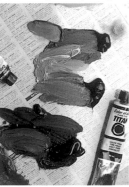

A dense but cloudless atmosphere has been achieved by increasing the tones of the background.

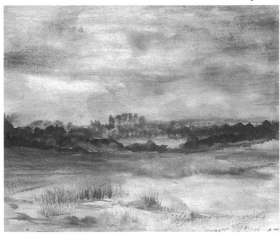

The highly dense atmospheric effect has been obtained by blending the tones of the landscape with those of the sky.

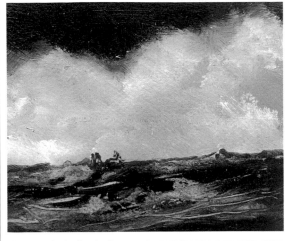

Shadow

The atmosphere increases its dramatic effect when the points of light are accented to contrast with the points of shadow or shade. The acrylic medium allows for absolute manipulation of the paint when it is worked in a moist state. This helps the artist add or remove tones from a specific area or simply saturate a certain tone to locate the center of attention over an area. In many cases, this is not done on the basis of composition but purely with the use of color.

Tonal Scale

After a specific atmosphere has been painted, if it is allowed to dry and pieces of adhesive tape are placed over it before applying a nearly transparent glaze, those areas will be more luminous when the mask is removed.

The atmospheric effect has been obtained by developing the different tones of white acrylic over a dry black background.

When studying the atmosphere, it is very important to analyze the tonal possibilities of the colors used, so as to exploit as much as possible the synthetic ability of both shape and color.

When depicting atmospheric effects, the study of light in the setting always has priority; therefore, developing the maximum tonal capacity of the color used is the best tool you have.

In the composition of this painting, the lights produced by the atmosphere have been studied as part of the composition.

Application of Atmosphere Outside of Landscapes

Obtaining an atmospheric effect is not only applicable when painting landscapes; any painting style can use atmosphere to develop separate planes within a work. It should be kept in mind, however, that the development of light has an effect on composition, and glazes or displacements of color that comprise the atmosphere have a direct effect on lights in the painting.

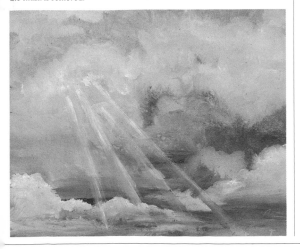

Original title of the book in Spanish: *Acrílico*
© Copyright Parramón Ediciones, S.A. 1997—World rights.
Published by Parramón Ediciones, S.A., Barcelona, Spain.
Author: Parramón's Editorial Team
Illustrations: Parramón's Editorial Team

Copyright of the English edition © 1997 by Barron's
Educational Series, Inc.

All inquiries should be addressed to:
Barron's Educational Series, Inc.
250 Wireless Boulevard
Hauppauge, New York 11788

International Standard Book No. 0-7641-5011-1

Library of Congress Catalog Card No. 97-71319

Printed in Spain
9 8 7 6 5 4 3

Note: The titles that appear at the top of the odd-numbered
pages correspond to:

The previous chapter
The current chapter
The following chapter